Chicago People

RICHARD YOUNKER

University of Illinois Press

Urbana and Chicago

Manufactured in China by Everbest Printing Company

through Four Colour Imports, Louisville, Kentucky

1 2 3 4 5 C P 5 4 3 2 1

∞ This book is printed on acid-free paper.

Photographic prints of the images collected in this book were made
by Photobition, formerly Gamma Photo Labs.

Library of Congress Cataloging-in-Publication Data

Younker, Richard.

Chicago people / Richard Younker.

p. cm.

ISBN 0-252-02679-9 (cloth : alk. paper)

ISBN 0-252-06993-5 (pbk. : alk. paper)

1. Chicago (Ill.)—Social life and customs—Pictorial works.

2. Chicago (Ill.)—Social conditions—Pictorial works.

3. Chicago (Ill.)—Biography—Portraits.

4. Minorities—Illinois—Chicago—Portraits.

I. Title.

F548.37.Y67 2001

977.3'11033'0922—dc21 00-013138

To Judy

PREFACE

You won't see the men and women pictured here on society pages or hobnobbing with the mayor, although they might be quickly ushered in and out of a committeeman's office.

Many survive by wit and cunning, negotiating a path between law and outlawry on Chicago's streets.

None develop shopping centers or housing complexes, although they pound the buildings' foundations, hoist and tie their reinforcing bars.

Others are scorned and feared. They prowl street corners, weapons tucked under their sweaters, protecting those who sell narcotics.

None of their abodes will be splashed across the pages of *Better Homes and Gardens*. Some of these people will awake curled up under viaducts, shivering among the weeds.

None of them have lectured on Alexander's travels and adventures, yet some of them did ride the old steam engines, pitching coal into their bellies and feeling their thunder grumble through the cities, over the plains.

The people pictured here live close to the edge. They experience things that we can only imagine, little epics heard in the voices of those recorded here, etched into their faces.

■ ■ ■

This book arose out of a long journey. For most of the trip, like a fortuitous traveler, I was unaware of the final destination. And yet my background had already dictated its course.

I grew up in Younker's, my father's restaurant, and worked alongside the men and women in his employ. Before I buttered biscuits or greeted customers, Jens, the Swedish bartender, would hoist me atop a chair placed on a table and steady my two-year-old legs as I replaced light bulbs.

Over the years I watched the ceremonious mixture of creeds and colors—Irish, German, African American, Hispanic—pull together for my father's business. He had a fondness for them and they, in turn, revered him.

In time I learned much about them and about my father. I heard Sterling, a black man who turned out wonderful cakes and pies, tell how his aptitude for

electronics had been thwarted because of widespread discrimination.

Over dinners at home, Dad would relate how he, with three years of college, would represent in court a doorman or dishwasher who had not read or had misunderstood the fine print on some purchasing contract.

I began producing photoessays for the *Chicago Sun-Times*'s Sunday magazine, *Midwest,* in the mid-1970s. Later I photographed pages of working people and various ethnic groups for the *Chicago Tribune*'s Sunday magazine and for the *Chicago Reader.* Assignments for *Chicago Magazine* led me to other occupations and neighborhoods, particularly in multiethnic Uptown.

Until 1985 these essays represented nothing more than small legs of a photojournalistic itinerary. Then Arthur Gould of the Chicago Review Press suggested that I combine my photographs with quotes from their subjects—members of street gangs, railroad workers, pool hustlers, construction tradesmen—and sequence them into a book. My first such venture was *Our Chicago: Faces and Voices of the City,* which was published in 1987. It included forty-nine photographs and forty-three monologues, largely about laboring people, and received considerable and kind notice.

Chicago continued to have a hold on me. Toward the end of 1988 I received a one-year grant from Focus Infinity to document life in the city's Polish neighborhoods, a project that I continued for several more years on my own. Unbeknownst to me, I was creating another book, one with a wider range than the first.

My mood had lightened by the late 1980s, and it was reflected in some of my subjects' faces. I went back through my files and found pictures with wider perspectives to complement the tighter, often grim street portraits of *Our Chicago.* The result is *Chicago People,* which combines forty-one of the photographs and monologues from that first book with forty-four new photographs and monologues. A number of these monologues are spoken by someone other than the person in the accompanying photograph.

Chicago People is a paean both to those who worked for my father and to my father, who introduced me to them and to himself through them.

Chicago People

Street Entrepreneur

Oh, there be all kind of mixed-up people on
the street, Rick. Sometime you run across
a addick, have a three-hundred-dollar camera, but
he got the shakes so bad, you know where he just have
to get himself straight, he sell it to you
for forty dollars. I ain't lyin'. And then
I come back and get a hundred and fifty for it.

But y'always have to have that cash money.
Don't be carryin' a checkbook. Mmmhmm!
No good. You give me a bad check then what
I gonna do? I'm stuck. But if you give
me counterfeit money, I can get rid of it.

Holy Trinity Polish Church, 1118 North Noble, June 1991

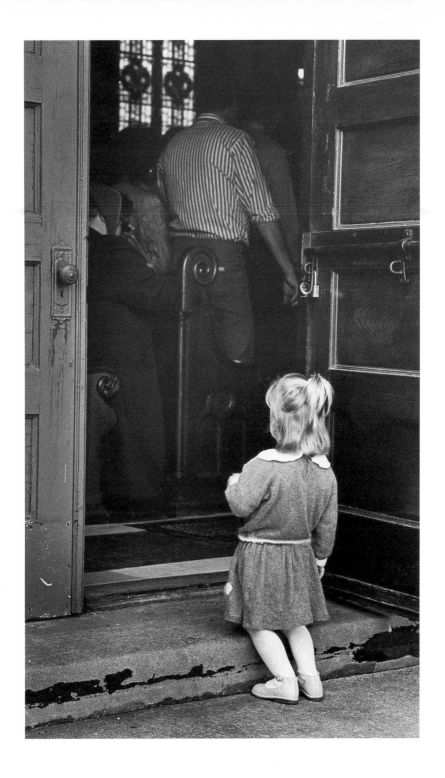

Boy in the arms of a statue, Stockton and Fullerton,
October 1973

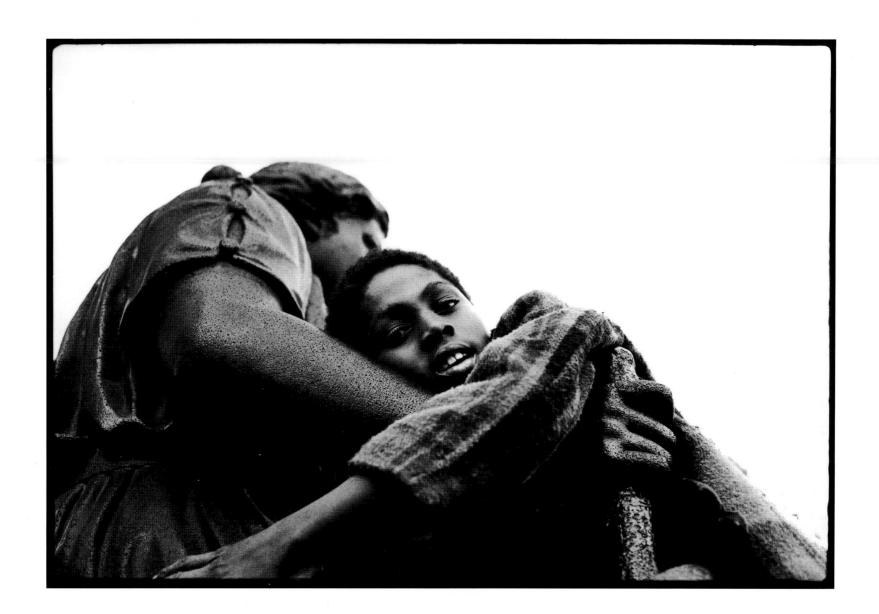

Carnival worker near Clark and Addison, May 1974

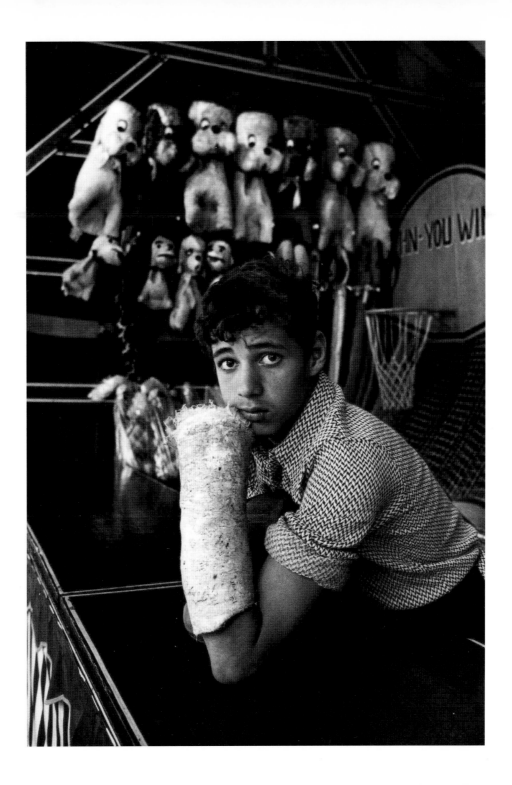

Backyard scene, Wellington and Lakewood, July 1975

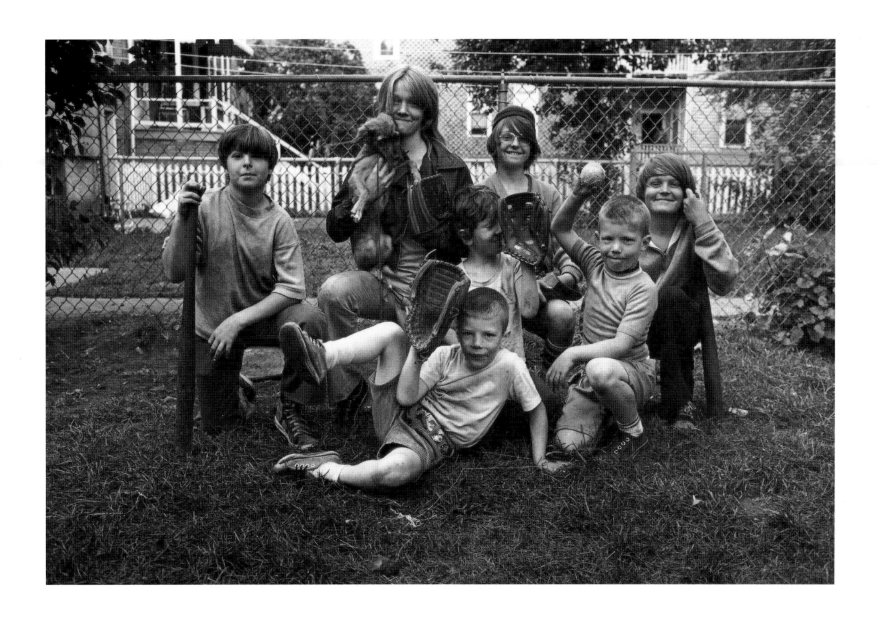

Little Enclaves

A lot of these people come to the U.S. and settle in neighborhoods like this. Why move, huh? Sure, look at all the stores and shops. Do you see any signs in English? Not for blocks. The clerks speak Polish, and then the foreman speaks it at the factory too.

Some might live here forty years and never understand a word of English. No, most of 'em look upon these enclaves as the little villages they left back home.

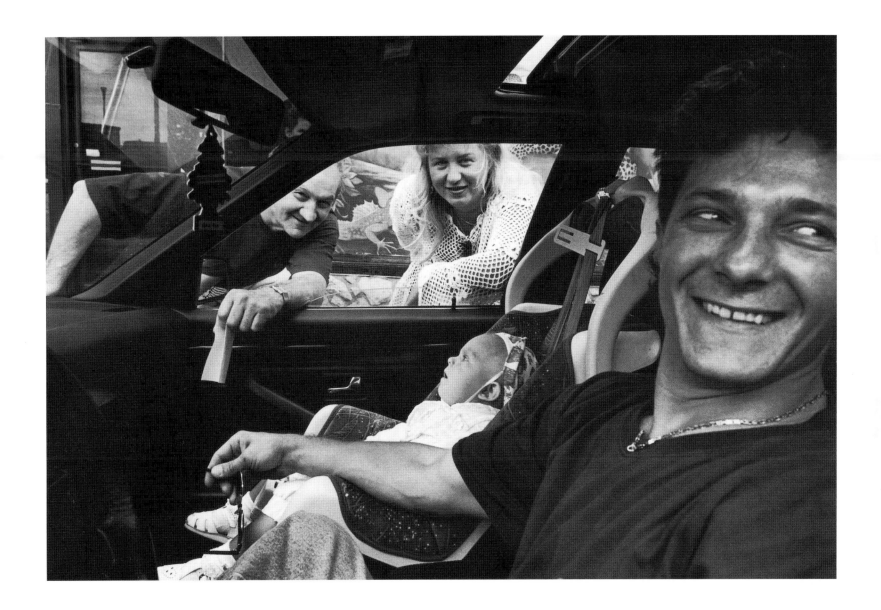

Speaking Polish

When I work at O'Hare Airport I practice speaking English every day, getting much better, but since I have another baby I stay home, now is not so good. And my oldest boy, he won't speak Polish to me. And only little bit with his father. He don't like it. Why is that, mister? You American, you understand this country.

Because he know it good; he even go to school on Saturday to learn his parents' language. Top marks. But now not with me.

If not with me then how will I get him write letter to his grandmother in Poland. She wait to hear from him. But he don't. One time she call on telephone and ask for him. He say to tell her he not home. Refuse to talk to her because she don't know English. Oh, this hurt me very much. But what I gonna do about it? Tell me, mister, what I gonna do?

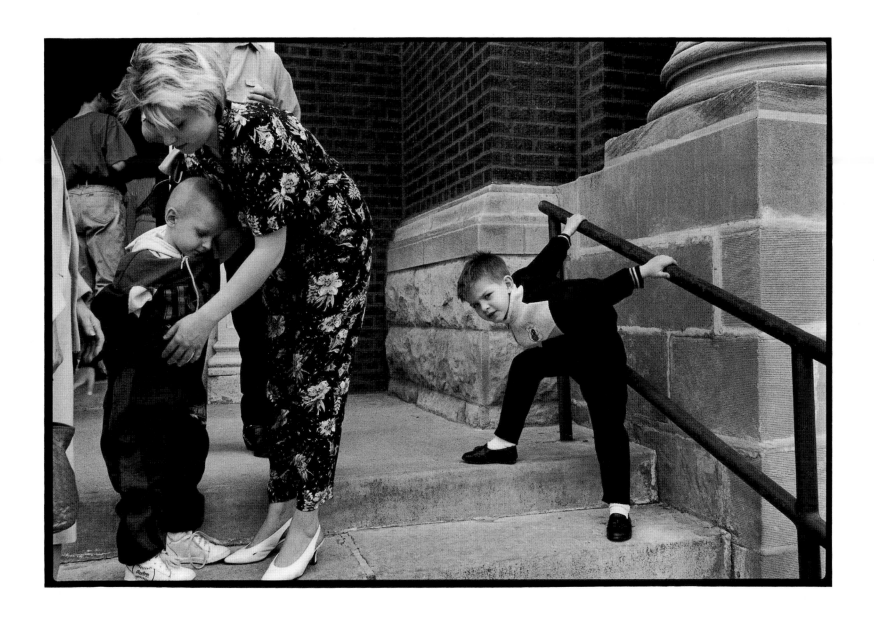

Mother and son at Holy Trinity Polish Church,
1118 North Noble, May 1990

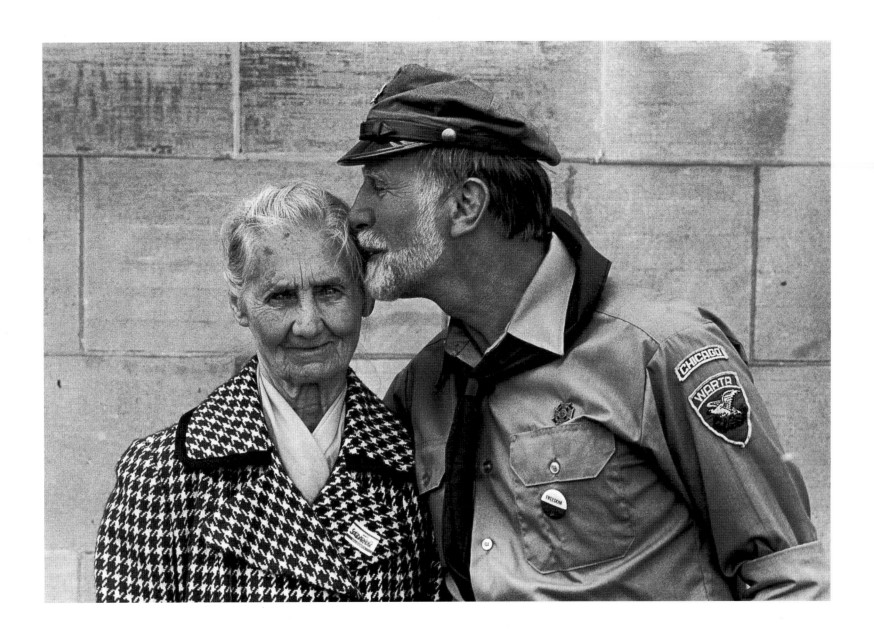

Miss Oh-So-Tired

We'd work from "can see" to "can't."
Go out when it was just light enough to see shapes
and then keep on 'til way pas' dinner. It be
so dark they had to weigh them bales by candlelight.

All day long in that field. All DAY long! So hot
you could see monkeys jumpin'. And then the hay
catch fire. No, I ain't jokin'. Down South
they used to grow this wheat straw. Set it out in piles
to dry, but after 'while the sun get so strong
on it, it just whoosh up in flames. Start
burnin' and wouldn't be a match for miles around.
Then everything go up. Acres and acres!

When I was fo'teen I told my momma,
I said, "Momma, one day I'm gonna leave
 Mississippi."
She say, "Oh, girl, you get used to it."
I said, "No, Momma! I don't care if I have
to ride the back of a mule or if I have
to go walkin', but I'm gonna LEAVE Mississippi."

But honestly, I don't think young people today
knows what hard work is. I'm tellin' you! It's like
my daughter. Sometime I jus' don't understand
 her, Richard!
I mean she graduate high school and she have
a good job. It's nothin' hard; she just sit
up in a office six or seven hours.
But on Sunday when I aks her do she want
to go to church, she say, "Oh, Momma, I'm
so tired." I say, "Okay, Miss Oh-So-Tired."

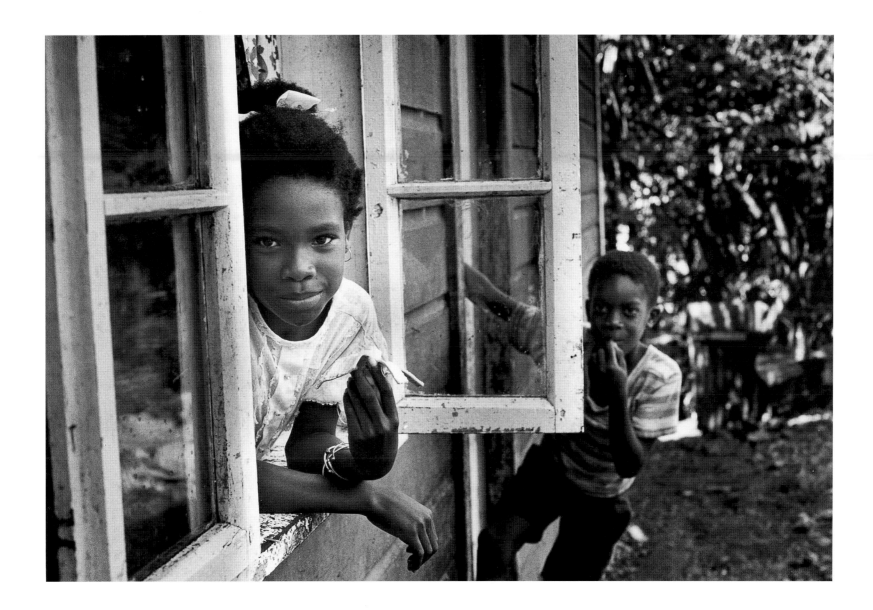

Mover

I was at the library with my kids the other day, readin' this here book about slavery. And then I thought about my father. I said, "Yeah, the old man could slip right between the pages and no one be surprised." People called him everything. That Scrooge is just the latest; Hitler, Stalin, you name it.

He used to say, "Just give me six good men!" Or, "I could make a call to Alabama," he'd say, "an' get a bunch of 'em and make some real money."

"Okay, Pop," I'd say, "but none of 'em could read, they couldn't find no addresses. Or worse yet some of 'em could read."

He put me on the truck when I was ten. We'd work from six A.M. 'til midnight. Move three families a day. Just fall down and sleep right in the cab. And then next morning when we'd be havin' coffee and donuts, that's all he give us money for, why he'd come bustin' in the restaurant shoutin', "Alright, get in the van, let's go!" And when the waitress said, "They ain't even finished their breakfast yet," he'd say, "They can eat any time."

Five years ago about this time he got a man from Georgia. There was about a half a foot of snow, not warm like this here today. Okay, we got to the place in Evanston and start unloadin'. Next thing you know the lady says, "No sir! he ain't comin' into my house!"

We say, "What's the matter?"

She says, "Just look at him!" We didn't see nothin'. "Haven't you seen his feet!" she screams.

We look down and darned if he ain't got no shoes on. Six inches of snow and all. Didn't bother him, he said. Said he worked better barefoot.

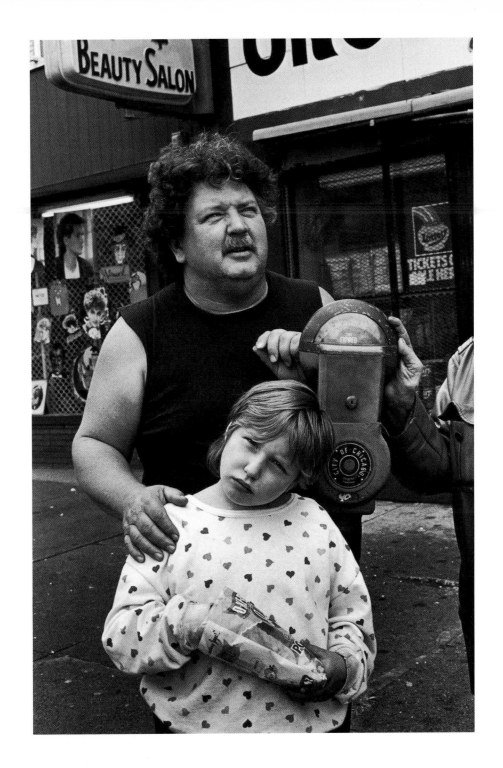

Southern Ways

I don't know what it is, the city'll turn a man against his brother. Back south it's so relaxed. We never locked our door or took our keys out of the ignition. Never thought about it. But in this here Uptown, boy, it's something else.

Might have some fella over to the house, a guy you thought was your friend. After a while you excuse yourself, you know, and by the time you pulled your zipper up, he done cleaned out your apartment. So help me. Probably happened to every one of us standing here. Maybe only once, but it did. I sure do miss them southern ways.

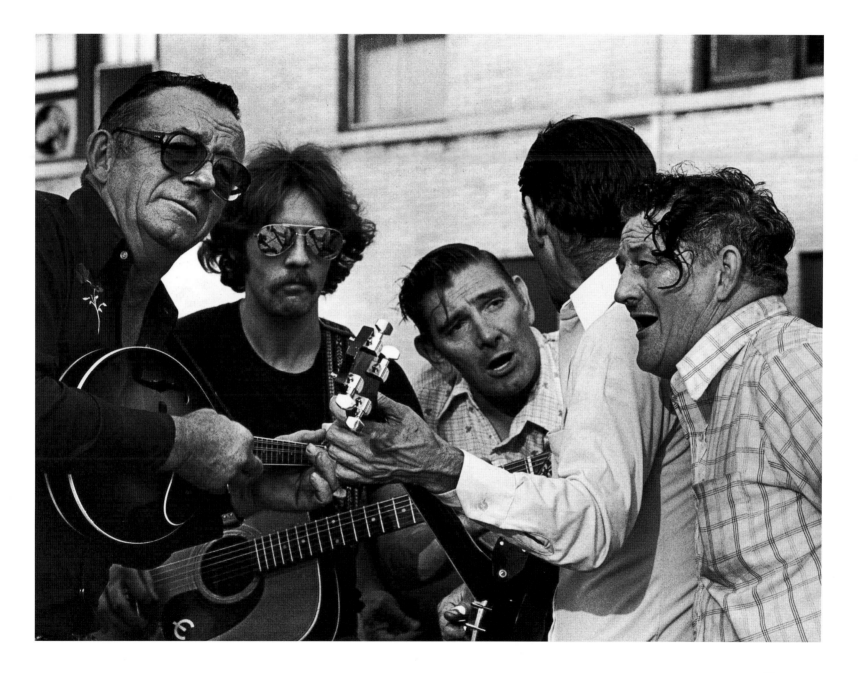

Haircuts

Saturday mornings when we open a half a dozen peo-
ple are lined up to get a chair. They take numbers. Oh,
people come here from all over the city. They don't
find barbers to cut their hair the way we do. There's
some on Madison, Roosevelt Road, but they all got
that West Side attitude.

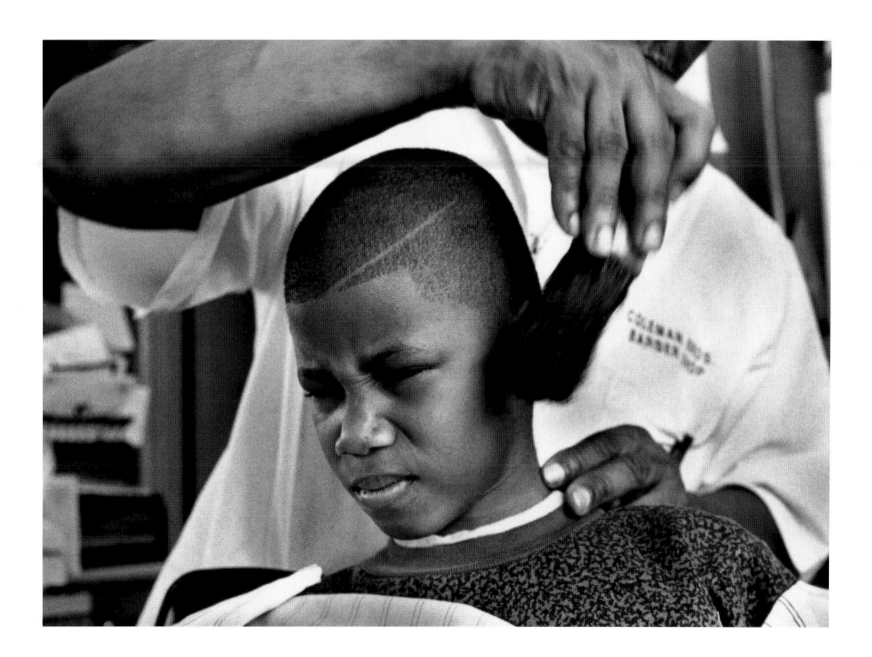

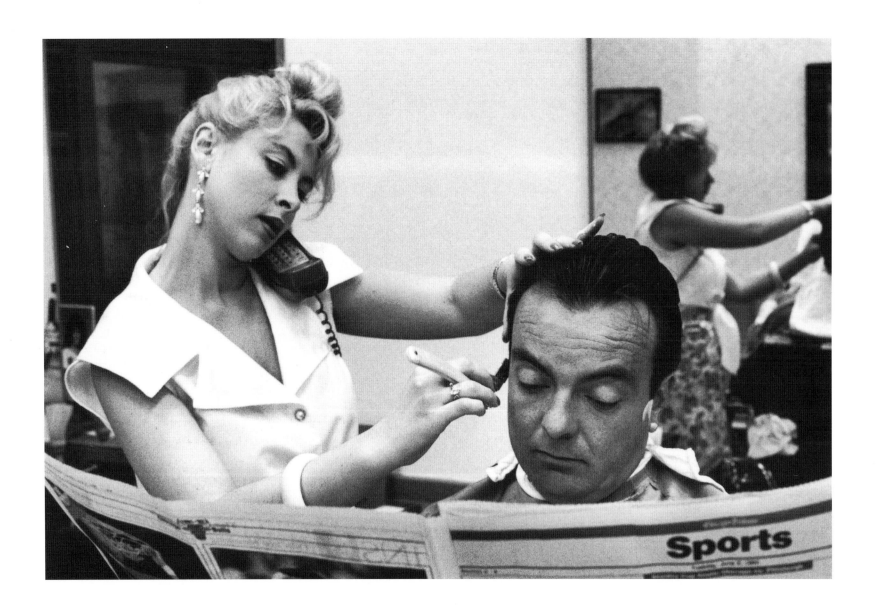

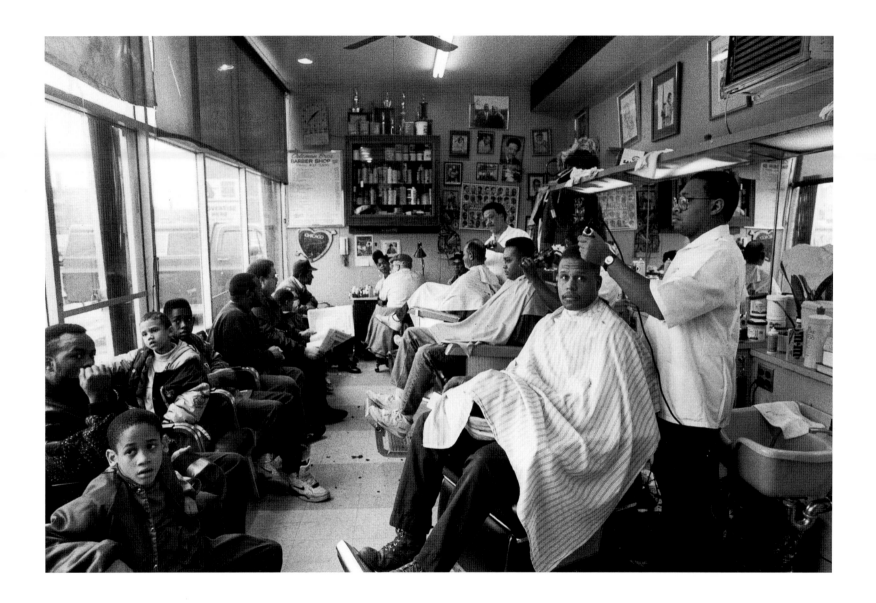

Scene at Humboldt Park, near 14th and Humboldt

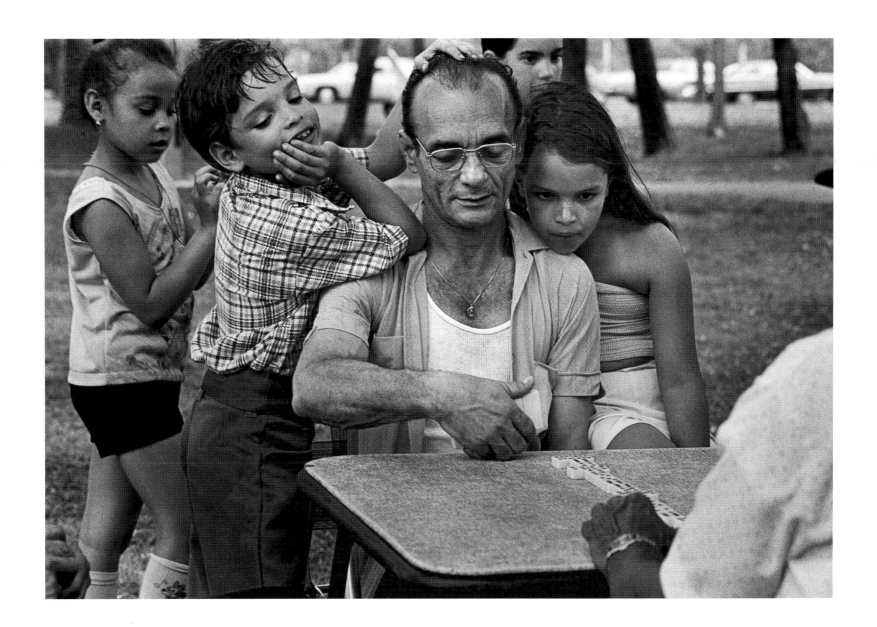

Innocent

We joined the Gaylords about three years ago.
Before that, everybody was doing it,
I don't know why, we were in
the Royals. Before that we were innocent.

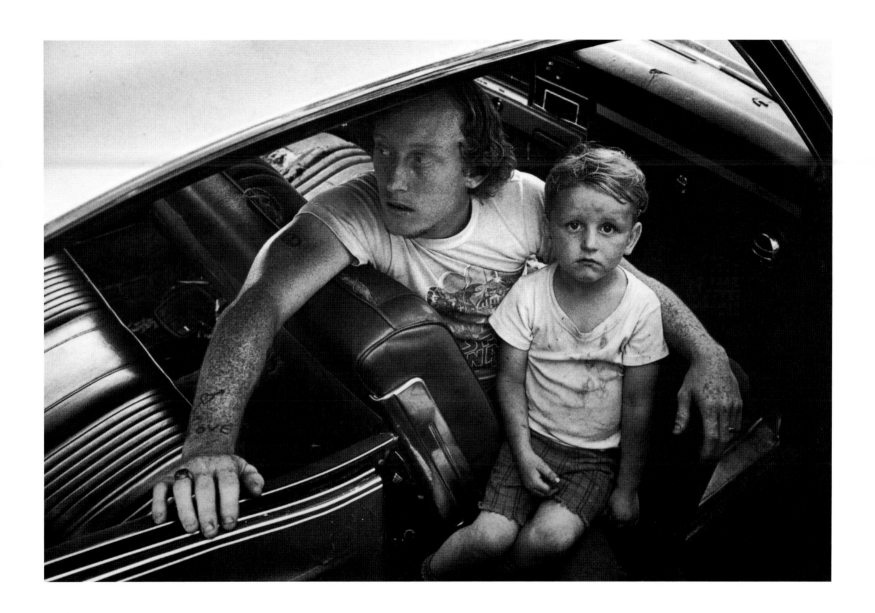

Initiation

. . . you can defend yourself, put up your hands
or move around, but it ain't gonna do
no good, 'cause they be comin' at you
with everything they got. They hit your face,
your chest, just about anyplace. But if you take it,
if you still standing after thirty seconds, you a
Disciple. That's how you join.

To get out? I don't even want to think about it.

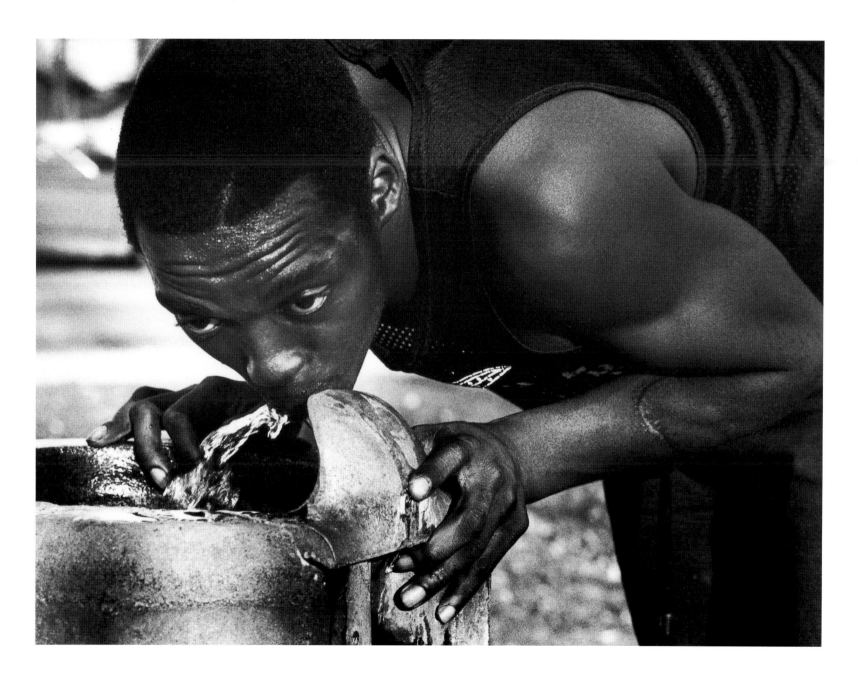

Nickel Plate

We was on Division and this guy comes 'round
the corner, hollerin'. Some goof,
we think. But he keeps shoutin' and when we turn
around he's got a nickel plate in his hand,
holdin' it up. And then he starts shootin'. I mean
he was about from here until that tree. And then
a guy jumps out a doorway, 'nother from
a car, another and another; must-
a been fourteen guys openin' up.

And we got outta there in a hurry, Jack!
But I got hit above the elbow, Jesse got
one in the leg, José and Ralphie, all
of us got hit. Except my mother, she
was with us, but they didn't get her. Couldn't hit
her, man. Because you can't replace a mother, right?
I mean a guy might have a hundred fathers,
a thousand maybe, but he only got one mother.

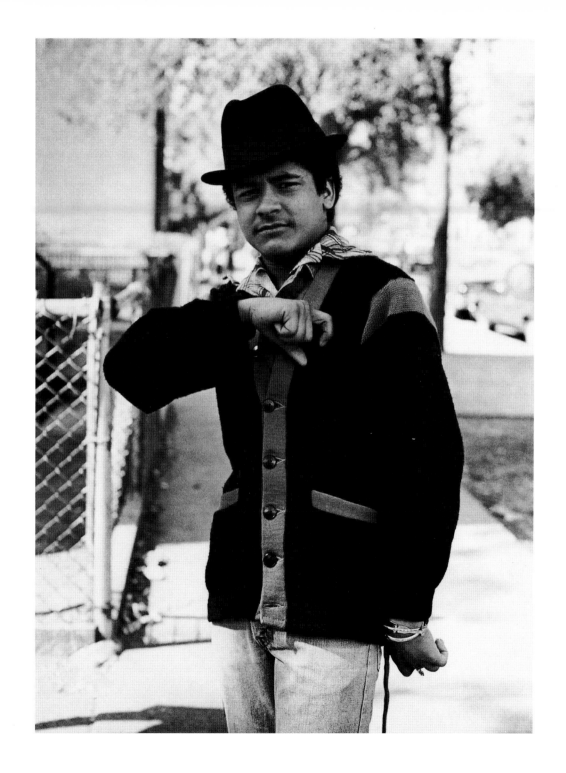

Mister Future (Street Gang Leader)

My name's Ray,
they call me Mister Future, you
probably read a-
bout me in the papers.
They call me that, see,
because I've ripped
a lot of people,
I've offed a lot of people,
but I've never gone to jail
or nothin'.
But everyone around here says
it's gonna happen,
someone's gonna do me in later on.
That's why they call
me Mister Future . . . yeahhh.

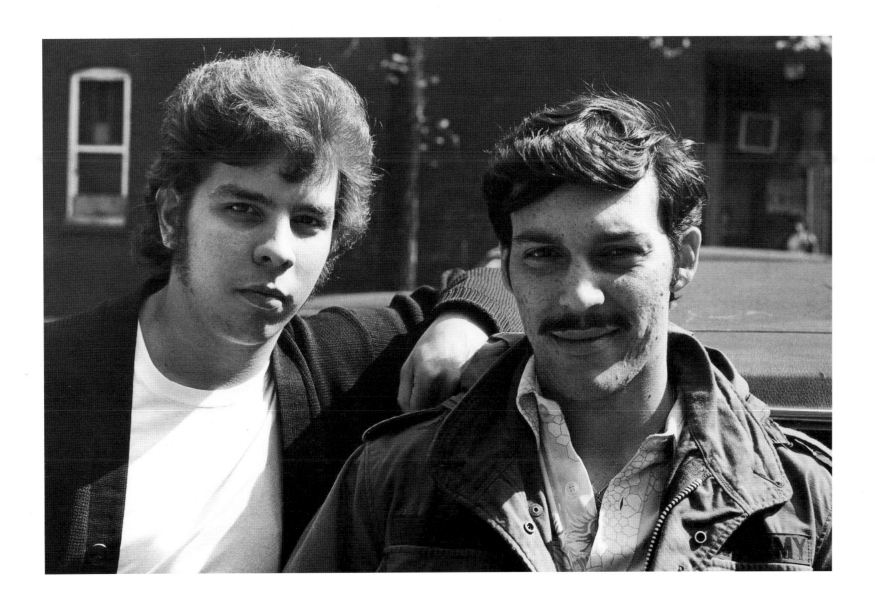

Sweaters

And like those sweaters. If you walk into another gang's block you gotta take it off, carry it over your shoulder. Then they might stop you and tell you to throw it on the ground, say throw it down or we'll kill you. Then they tell you to spit on it. Now if you don't spit on it, they'll blow you away. And if you do your own gang'll kill you.

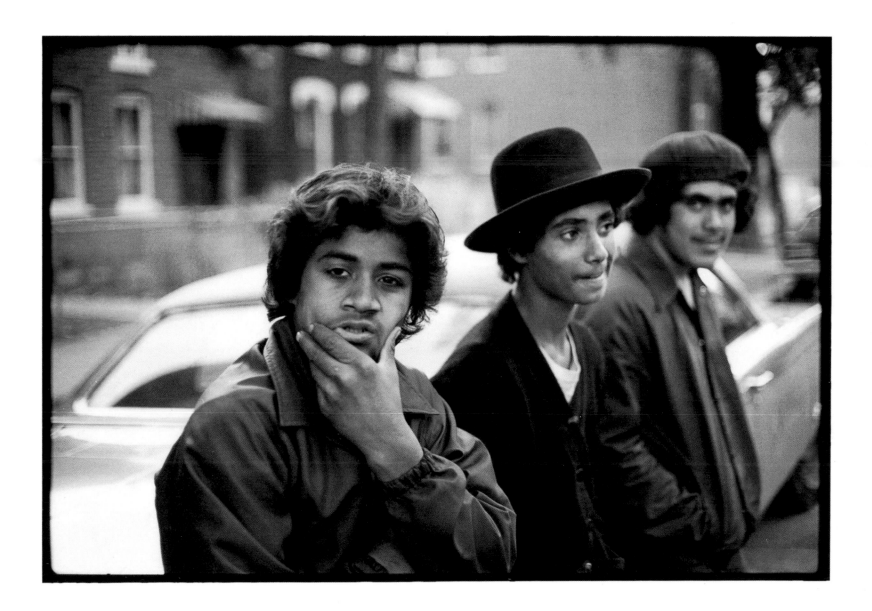

"...he won't look me in the face."

Check out the _____, the guy with the scarf around his head. That's where he took a bullet. I still don't know how he lived, man. I wonder who got him, don't you, Alvin? Heh, heh. See him stare down at the sidewalk. Yeah, he won't look me in the face. Punk!

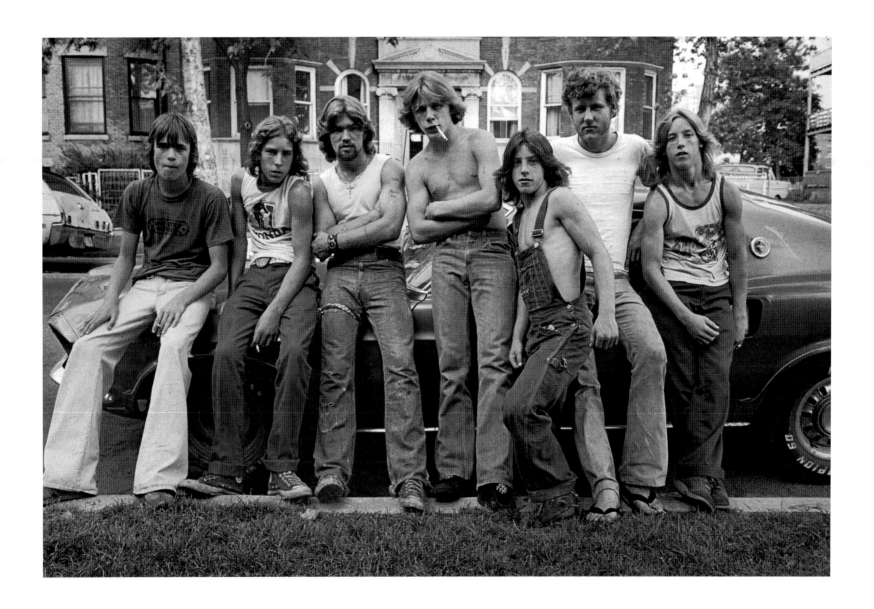

"I thought these people were hicks . . ."

You know what? In the gangs you don't have any friends. It's everyone for himself. They shoot you in the back if you don't watch out. Take your girlfriend. Sure, guys in your own gang.

I used to be president of the Latin Disciples. And like my members, I thought these people were hicks, singing hallelujah, glory to God, and all that. But then one day I said, Why not give them a try? Because I wasn't going anywhere.

Hey, who needs a forty-five to be macho? I'm much more a man for following the Lord.

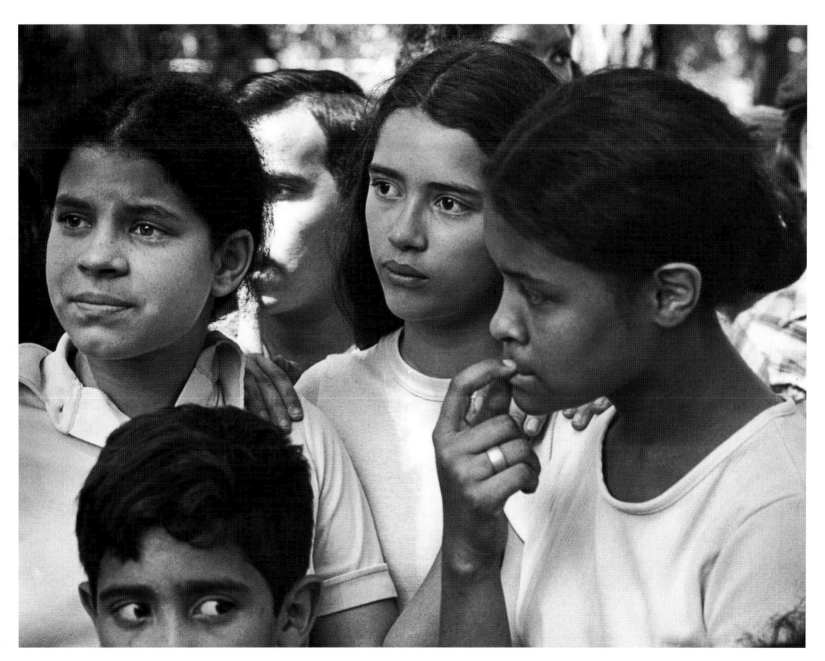

National Anthem

Not long ago they held a mass to commemorate the
Battle of Monte Cassino, where Polish soldiers routed
Nazis to open the Allied advance on Rome. Afterward
everybody went to the church basement for coffee
and donuts. Roman Pucinski spoke and then intro-
duced a lady to sing the American national anthem.
What beautiful, clear notes! But there are only three
or four reedy voices, so thin you hardly hear them,
accompanying.

 "Now," said Roman Pucinski, "let's all sing
'Jeszcze Polska Nie Zginela,'" the Polish national an-
them. Well, she hadn't let out two or three syllables
when the whole church joined in as one. Hundreds of
hardworking Polish men and women, people who
came from the farms and mountains back home . . .
strong people with big chests, pouring out their
hearts. Noise like standing beside a giant waterfall.
By God! they shook the building to its foundation.

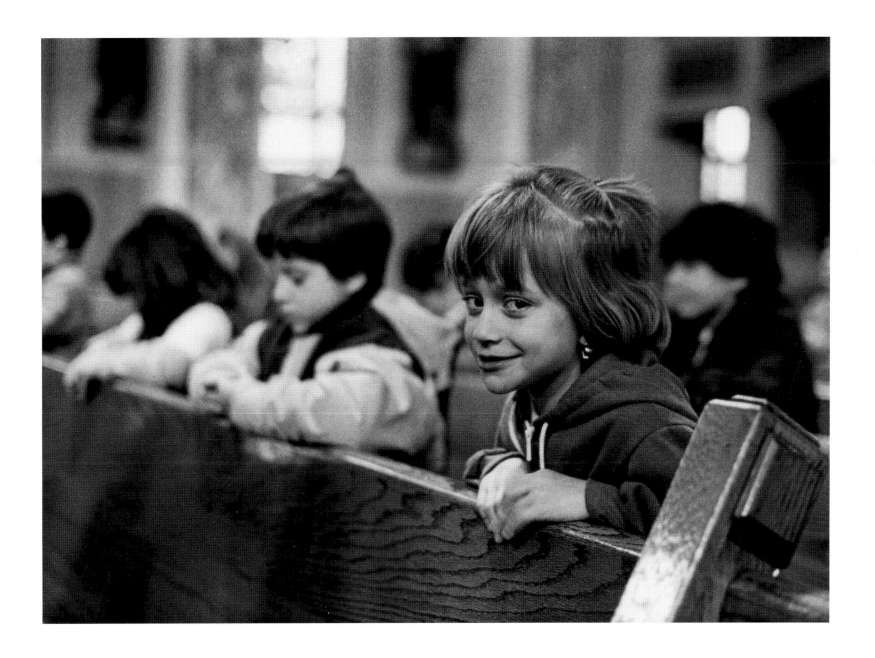

Buddha (A Narc's Tale)

Remember the DuSable Hotel? The old
sin palace? They had everything in there:
hookers and pimps, thieves, cutthroats, dealers, why
if one whole week went by without a murder, boy,
you sat up and took notice. There'd be
a lot of head scratching down at Homicide.
Matter of fact that area back then
was probably the worst in the world for drugs,
narcotics. Forget Calcutta, Marseilles; don't
even compare Harlem or Watts with
that little patch around 39th and Cottage Grove.

The coldest dealer in the neighborhood
was probably a guy named Buddha. Shaved
head, big bull neck, just two dark coals for eyes.
Well, we were trying to pin a bust on him.
Murder for one: he'd shot some people in
cold blood because he didn't like them,
others for more serious offenses.
I had been hanging out in the hotel bar
about two weeks and makin' it known
that I would like to buy some high-quality dope.
"Buddha's the man," the people there kept telling me.
"You got to see Buddha."

■ ■ ■

So one day they arrange for me
to meet this character. Ten o'clock I walk into
the nasty place. Remember how dark it was
until your eyes got used to it? Wouldn't be
no problem running into a knife the way
it was; they'd say you fell on top of it.
About ten cats was sitting at the bar, but
when I came in the conversation stopped.
You could have heard a pin drop. I caught
the bartender's eye and he nods to someone at
the far end of the bar. I go over to him.
"Whachoo want, boy?" "I want some good
 stuff," I said.
"I hear you got some H with a kick to it. Don't want
any of this funny talcum powder shit
that's been going around my neighborhood."
"You wanna try, you wanna buy?" he said.

"Well, let me take a taste of it," I said.
"I'll let you shoot it up," he said. "No thanks,"
I said. The word was out he cut his stuff
with ground glass if he thought somebody
 messed with him.
Heart-stopping stuff! Chill you in thirty seconds.
"Why not?" he said. I looked into his eyes.
Nothin' but two black coals inside the sockets.
They said it was like taking a lie
detector test to look into 'em.
"I'm buyin' for my lady," I said. "Oh yeah?"
"No need to be a prisoner," I said,
"there's someone else that I can keep a slave."

So two weeks and four buys later everything fit
together like a jigsaw puzzle and
we took that slickster and threw his ass
in jail, at least he thought he was slick,
and threw away the key.

Uncle's graduation at Rockefeller Chapel, 59th and
University, June 1991

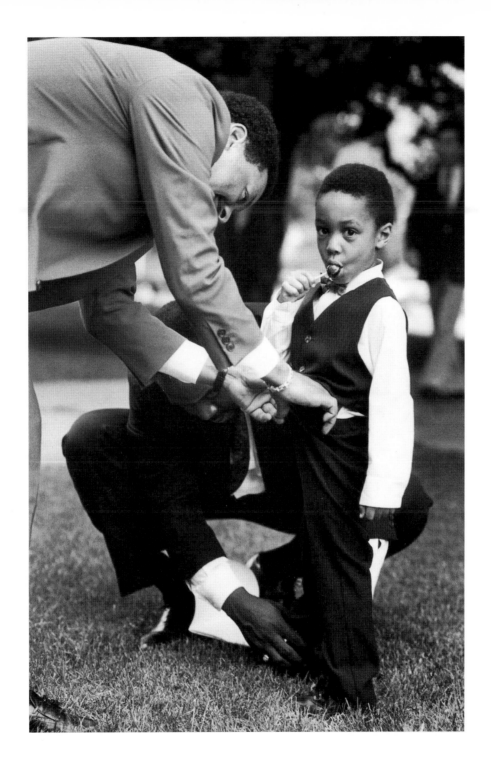

"I was the man . . ."

That's what I boxed as, a lightweight, just like
Jesse here. And I fought the best, Rich.
I fought 'em all. Scrapped Johnny Bratton for
the title. Twice. Almost had him one time.
Did you know I was the first man to knock
Johnny Bratton down?

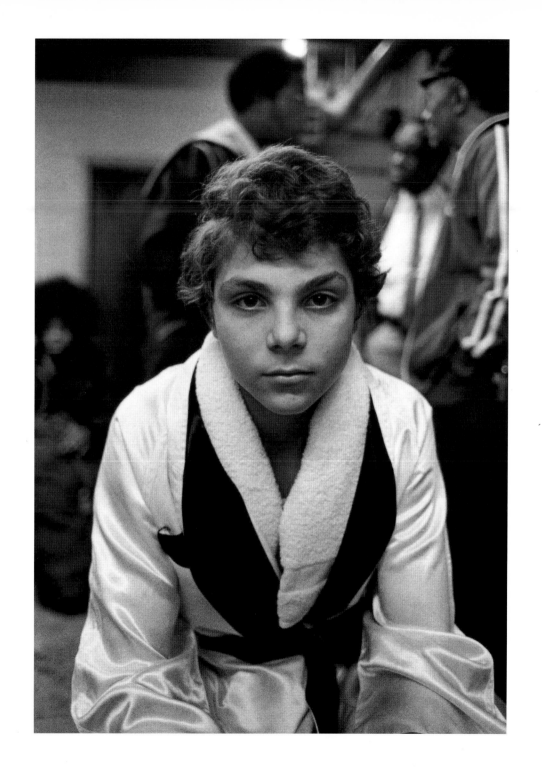

That's right. Oh, he
just hated to fight me! Back then I was
a boxer, see, fight weekends, but I danced
some too. On Friday nights I put on exhibitions
in clubs. Do Charleston, a little soft-shoe,
tap dance. And Johnny Bratton couldn't hit me, see,

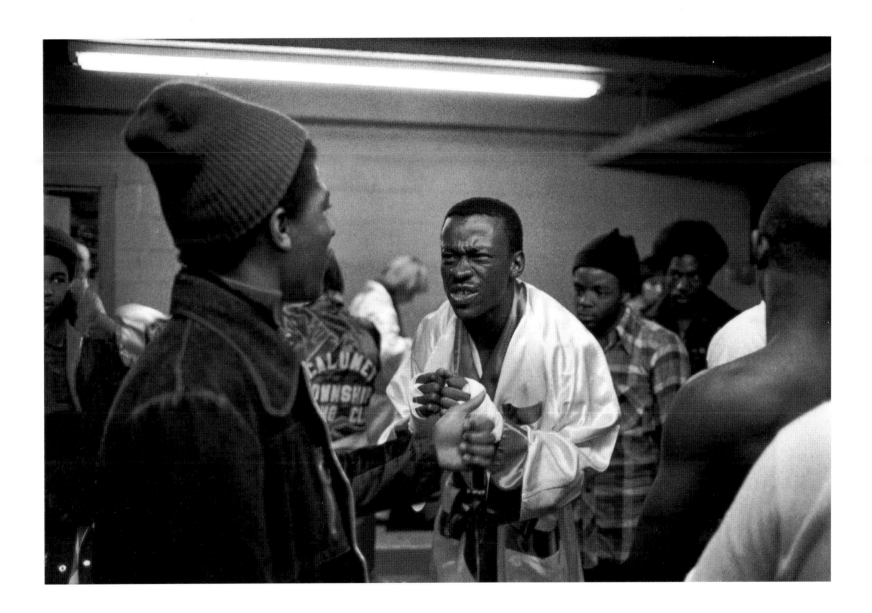

come out his corner throwing punches, see, just like
a windmill (oh, him and the Beau Jack
was murder if they ever catch you!) bull out,
but now I'd pick 'em off like this, whap-whap,
or do a little shuffle step and slip away
like this here, maybe sting him one.

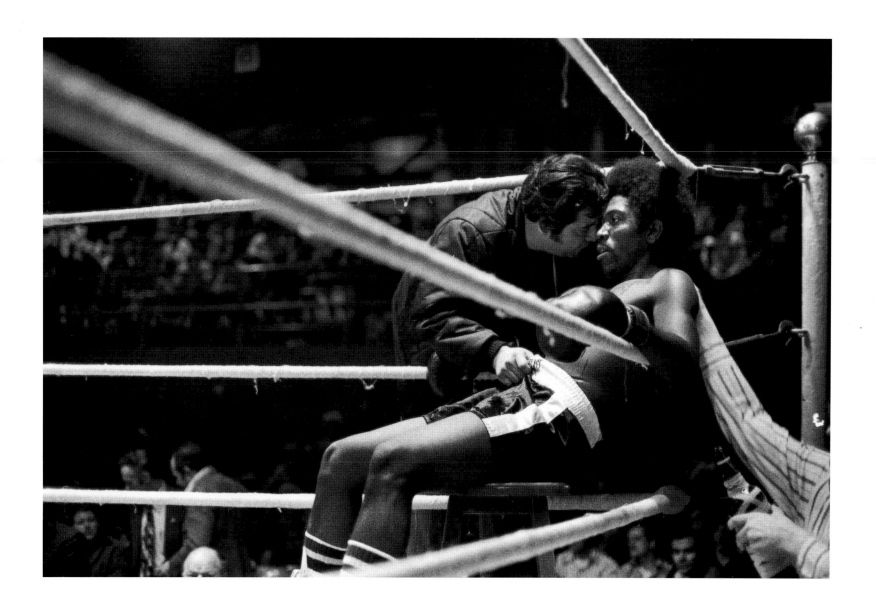

He'd be so frustrated. And then one time,
his trainer told me this, he got
so mad the tears rolled down his cheeks.
They did. Mmmhmm. Because of me. Yes, sir,
I was the man that made Johnny Bratton cry.

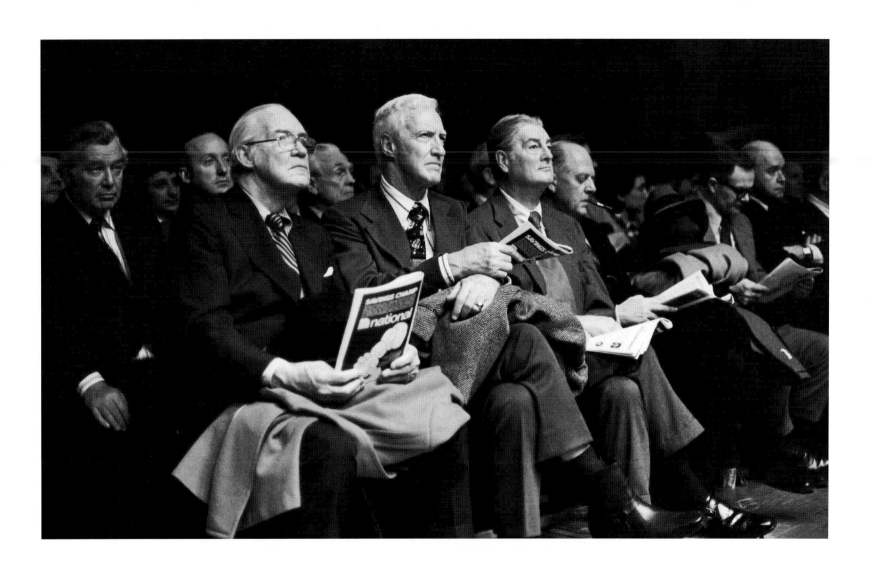

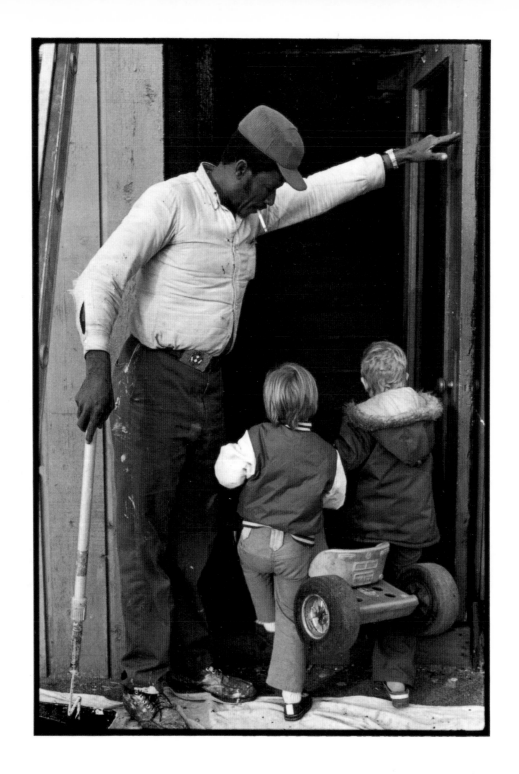

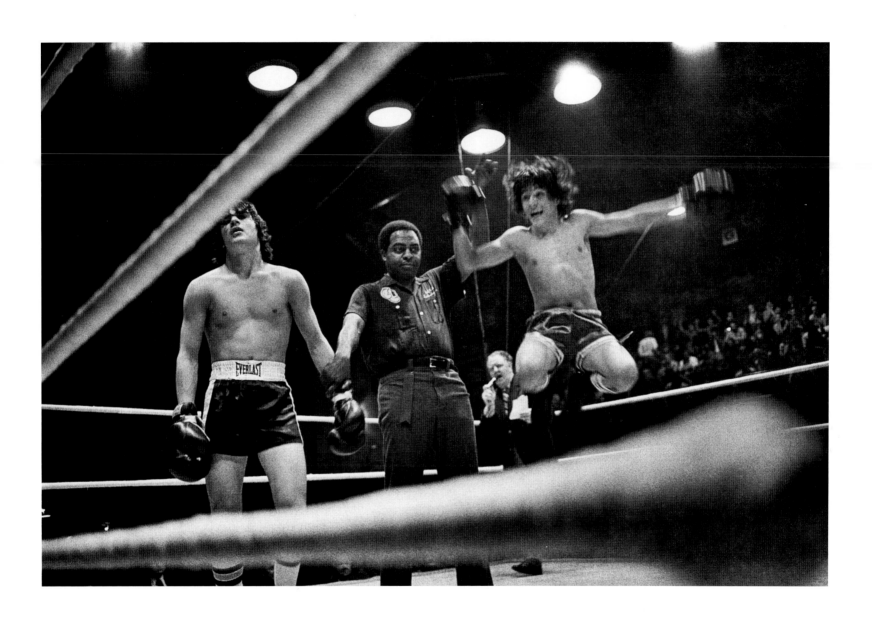

Local 1

We're in Local 1, structural ironworkers. Weld and
burn. Mostly supports and railings on railroad bridges.
Maybe a wreck damaged 'em or they just rusted out
with age. Like this one that runs over the Mississippi
at Hannibal, Missouri. Stayed on that job seven
months. 'S real pretty down there. Reminded me of
my hometown, Rosiclare, in southern Illinois. You ever
heard of it? Oh, it's a big one. All of about fifteen hun-
dred people.

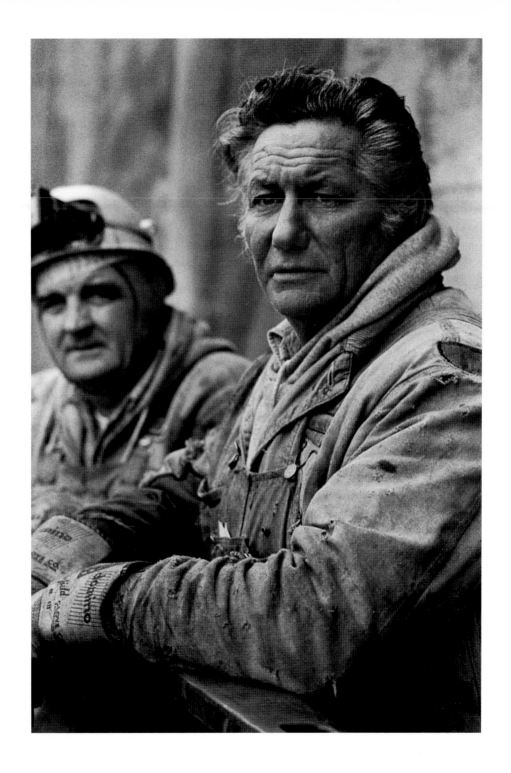

"What's your trade?"

All the construction workers used to hang out in
this bar on Lincoln Avenue. But, by golly!
it could have passed at times for the union
hiring hall as well. Because if a tradesman got
laid off, why all he had to do was socialize
in there a bit, then maybe after a couple
of glasses mention he was out of work.
"Say, what's your trade?" they'd ask him. "Wasn't you on
the Hancock Building? Carpenter! Come over
and meet the foreman!" Well, next Monday there
he'd be, out haulin' iron or sluggin' nails.
Of course, it didn't hurt to have a name
like Petersen or Jensen. Or O'Connor.

A lot of the higher-ups hobnobbed in there
as well. You might see some executive
take out his checkbook, think nothing of
it at the time, but two weeks later they'd
be excavating for a skyscraper or high-rise
because of it. Six months' guaranteed
employment for upwards of three hundred men.
In fact, I'd say there were more buildings built
in Tommy's than around all the conference tables
and drafting boards in the city and suburbs combined!

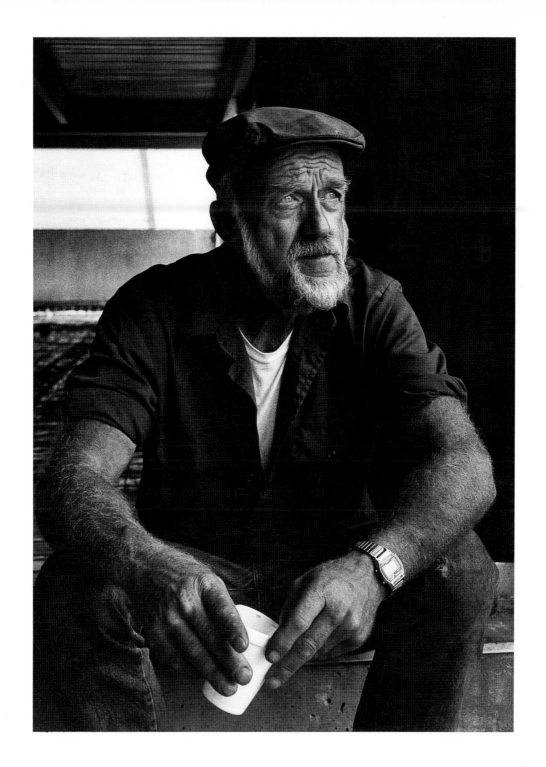

Pile Driver

I started out as pile driver t'irty years ago.
After t'ree months I get a bad headache. So
I got to see this doctor in Hahmund, Indiana,
where I was working. He say, "What you do
for a living?" I say, "Operate a pile driver."
He say, "You know how you cure them headaches? Find
another job." So I get on as carpenter about six months.
But dot give out so I go back to da pile driver.
And dot's da way it's been. A little bit o' carpenter,
a little bit o' pile driver; back and forth, back and forth.

I worked on dot filtration plant out at Navy Pier.
You know how many piles they got to drive out there?
A hundred fifty t'ousand! What a racket dey make, you don't
believe it! Now my right ear's dead, don't hear nothin',
and in da left is just a little when I turn up machine.
Today dey got dese plugs, but I never did like 'em.

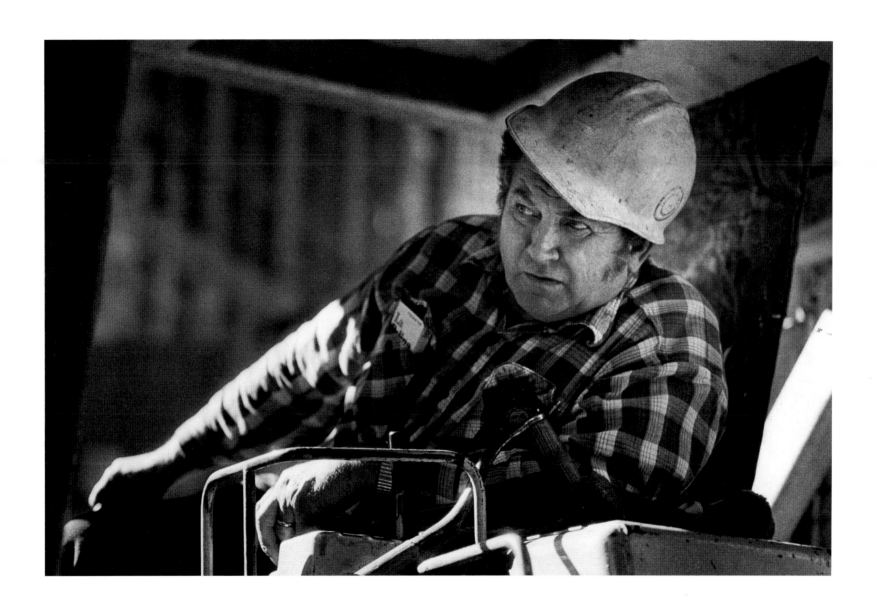

Ironworker

Me 'n' Joe work in rain, snow, everything.
On days so cold you won't see no one
walking' around, not even between
buildings, we're out here fourteen, sixteen hours.
All of the other tradesmen go home. We stay.

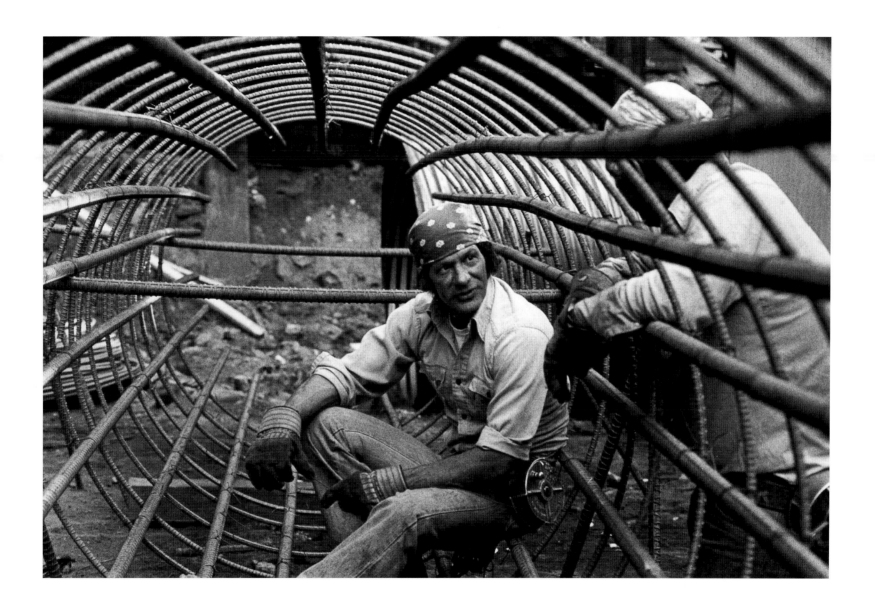

Heights

Bein' up here has no effect on me at all.
What makes it easy is if you work your way up.
On the first floor you look over the side,
and that's nothin'. Second floor's the same.
And so forth. We put up a building on North Lake
Shore Drive and when we got to the fortieth floor
I looked down to the ground one day and shouted, "Hey!
we need some iron," or I don't know, maybe
it was "Stacks up here!" Of course there was no way
they could hear me, even through a bullhorn, with
the wind blowin' and everything. But you get
so used to it, the goin' up floor by floor, that when
you reach the top, it's like stoppin' at the edge of the curb.
As if you're shakin' hands with the earth almost.

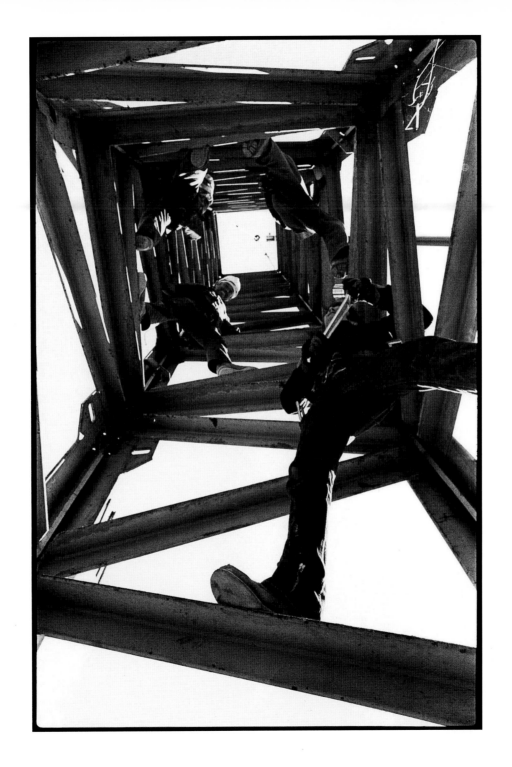

Industrial truck cleaner, 1400 North Magnolia,
July 1978

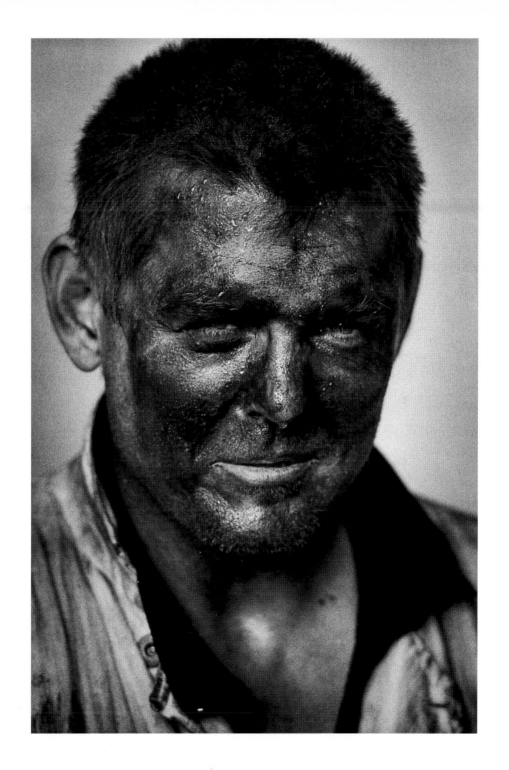

Ford Plant, 12500 South Torrance, June 1985

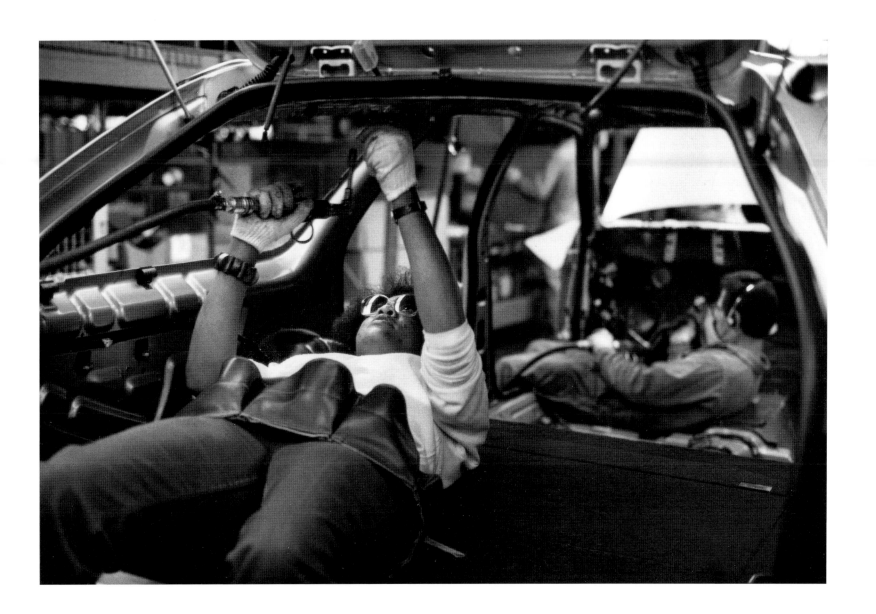

Salvage

I can make forty a day. Even forty-five, fifty. Some-time only net eighteen. That's okay too. 'Cause there's money out there. Oh yeah. Someone pass by this and all he see's a vacant lot. House knocked down. Another person, someone used to salvage, he see a gold mine.

Some of these young fellas haul off a hundred, hundred fifty a day. A day! But next time you see 'em, they broke. Stop you on the street, "Hey, Jimmy, you got a quarter?" I mean I'm fifty-eight years old; I go out and work six days a week.

But if you can't find a job, you got to scuffle. What I call myself doin' out here. An' I do alright. I do AL-right. Aluminum is fifty cent a pound, brass'll get you twenty-seven, copper's about fifteen; cast iron don't bring but two and a half. But it's good. When you ain't got nothin' it's all good.

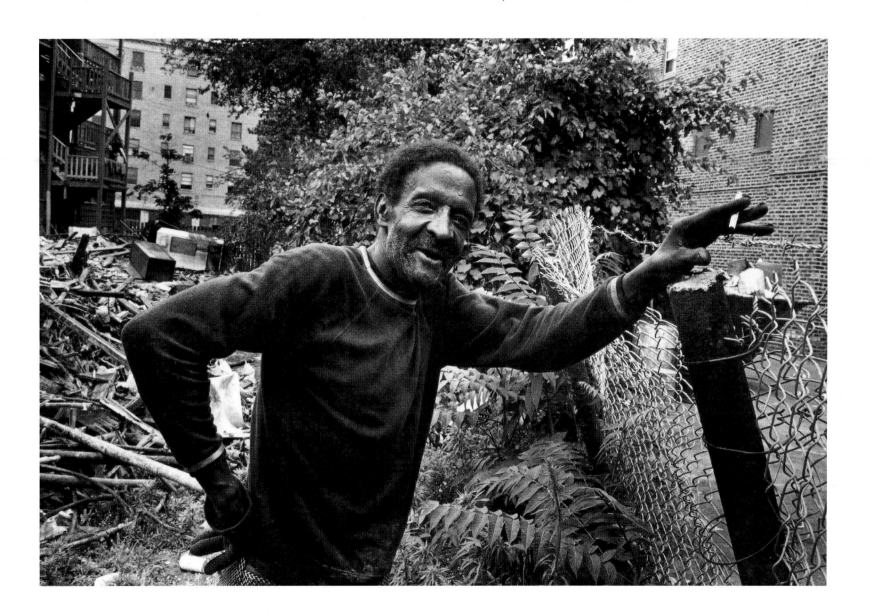

Brickchip

This just a little piece of job I got. Hard?
You bet it's hard work! First you gotta find
the bricks, then you gotta clean 'em,
and lastly stack 'em up.

'N' these bricks here is bad. Almost all
of 'em you gotta knock something off.
'N' that hurt your hand. It hurt
your wrist, it hurt your arms, it even go
down into your legs. 'N' what with
the rain we had, it makes 'em heavy as
they are again. Yeah! Again and again!

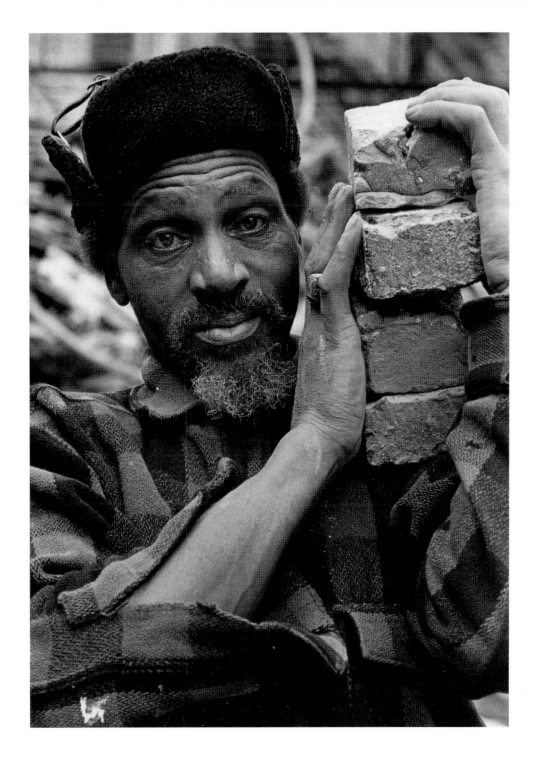

Pumpkin Salesmen

But, oh, the people, God love 'em. They see us in
our coveralls and right away
you know what comes into their minds: farmer . . . dumb.
Hell! we're part of the display. Two Santa Clauses.
And then we got our cornstalks stacked up nice,
the bushel baskets filled with fruit
and taffy apples for the little ones.
So if the public wants to think we're country,
let 'em. Don't hurt nothin'. Come one,
come all. Welcome. Everybody welcome!

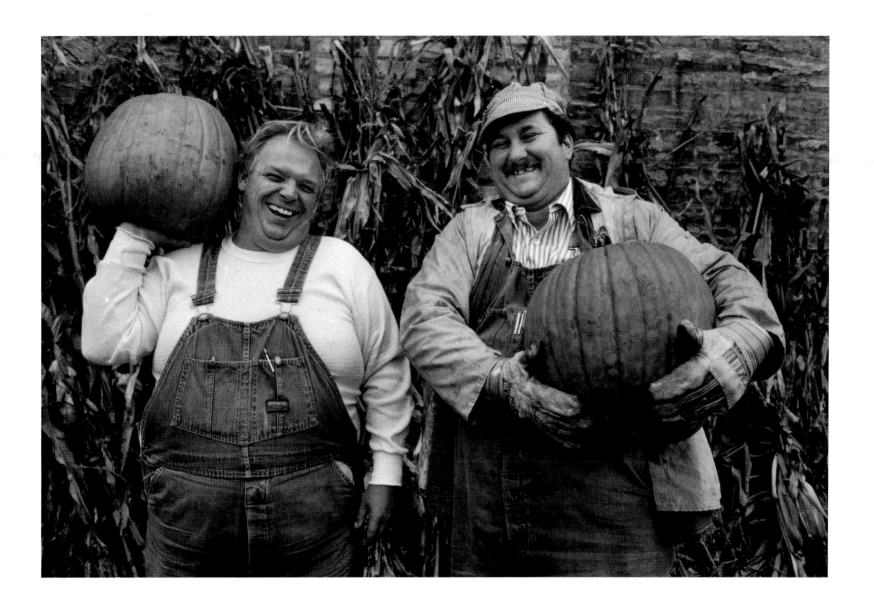

Street Music

The people in this country are in such a hurry; there is
so little quality to the life or the products. Everything
is accomplished quickly, shoddily made. Not only man-
ufactured goods, but the music too, most of which
you cannot listen to.

And don't even imagine yourself having a discus-
sion like this with an American or with some of my
Polish friends who have lived here some time. When-
ever I invite one to stop over or go to a café, they
always turn me down. "Why not?" I ask. "You know
what they say here," is the response, "time is money."

It's not like this in other places, believe me. I've
lived in fifty-eight countries, including ten years around
Africa, teaching, playing music, selling merchandise
in front of stores. One time me and my two buddies
were playing accordion on the street corner in London
and you know who stopped? Mick Jagger. I'm not
kidding. He listened about ten minutes, then pats me
on the shoulder, says, "Hey, man, you're good, keep
playing." Invited me to a party he was having at his
mansion that night. Really. We had a great time.
A regular fellow with both feet planted on the ground.
I don't care what they write about him in the papers.

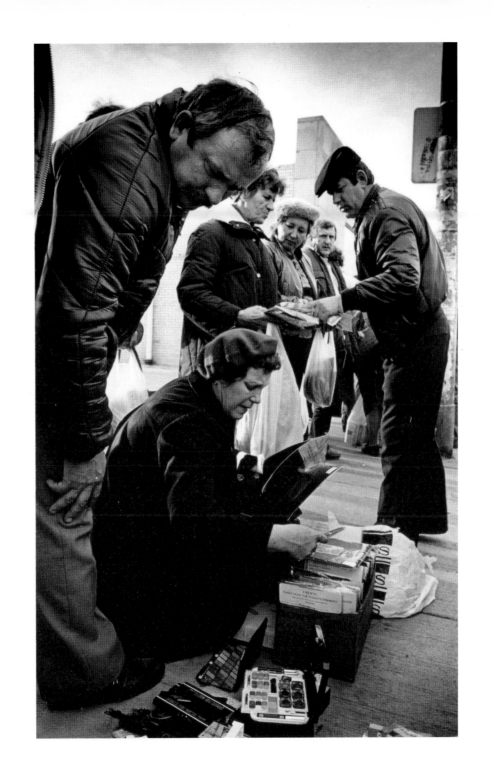

Drum Beater

That's me, that's my name up there, John Henry Davis.
Been playin' blues on this corner eighteen years.
My own boss too; ain't gotta listen to
nobody tell me how to play my music,
do I? Play the way I want to. But now
why can't this boy come out here and play? That ain't
no good. He 'posed to be here at . . . what time
that sign say we start playin' blues music down here?
Alright. This how I make my livin'.

Drum beater, drum beater! We need someone
 to come
up here and beat on these here drums.
Don't nobody know how to play no drum out there!

Now all my people musicians. My daddy was
a organ player, my mamma was a shake dancer in
a church. Lightnin' Hopkin' Davis, he
my uncle. Sammy Davis Jr., he born
back of a show wagon, Loozeyanna. Sho' wa'.
 He kin too.
Now I don't got no education. Can't read
no music. What fah? What I gotta read it fah?
I hear somethin', I play it. Somebody burn
that book-a music, then what you gonna do?
'Thout all them notes you lost, ain't you. But I
was raised in music, it something have
to be inside you, have to feel it.
To feel the beat. All th' education in
the world can't help you with that. Ain't that right?

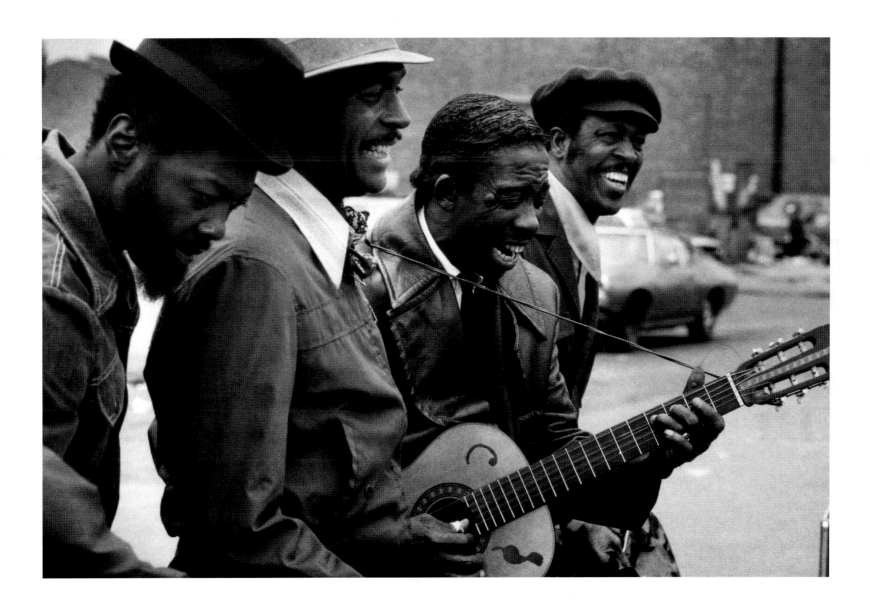

My own boss. Don't have to stick my nose up
nobody behind. Do I? I tell the band
what time to start, and when I tell 'em to quit,
they quits. Anybody else tell 'em what time? Tell
'em what to play too. Didn't go past the fo'th grade
and my own boss. Contractor too. Do paintin',
decoratin', construction. Thirty-nine
years old and never worked for nobody else a day in my life.

That way I be raised. My mother told me, said,
"John Henry, ain't nobody gonna gi'
you nothin' in this world; just one person you
can 'pend on and that yourself." And I
work seven days a week. Get up six o'clock in
the mornin' every mornin'; everybody else
be sleep, the kids, the wife. I step over 'em, make
my own breakfast and go on out the house.

Drum beater! Drum beater! Can't nobody beat
on these here drum out there! Dis ain't no small town
in Ahkinsaw, no crossroad down in Mississippi!
Dis Chicago. Windy City! Mean
to tell me all them people out there don't
nobody know how to play no drum. Drum beater! Drrrum beater!

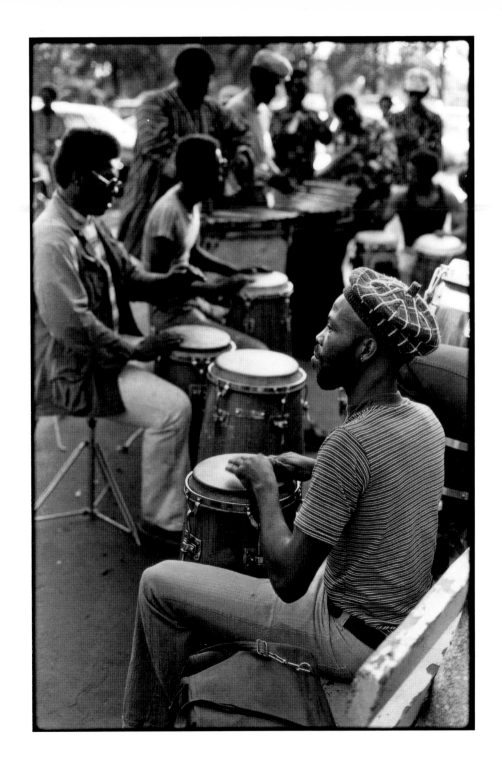

Playing at the old Maxwell Street Market,
November 1975

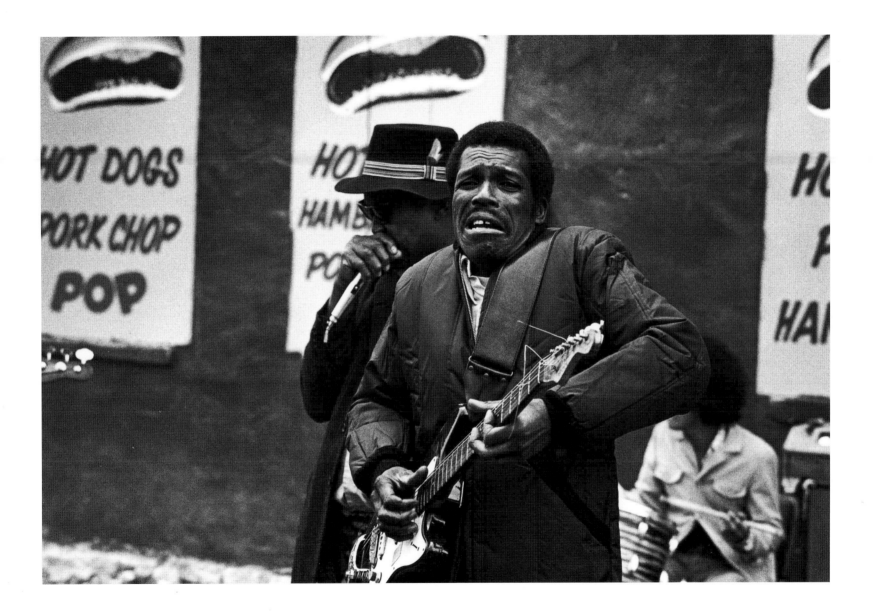

Piece of Cake

Why don't you go down to the station, get
a piece of the commander's birthday cake?
It's like the neighborhood. On one side, black,
the other, white. Oh, Jesus, that reminds me.
One time me and two officers were having a cup
of coffee over by 69th and Stony.
They had their pastries on display inside
a case. There was this cake that had a couple slices
cut out. I think it was white on top and chocolate
below. Yeah, I'm pretty sure. And then this guy comes in.
He's staggerin'. And all of us are holding
our breath, waiting to see what he's gonna do.

He sees the cake and goes berserk. "Just like
your white society!" he shouts. "Who's always on
the bottom!" Then before we could react
he's grabbin' people off the stools and throwin' 'em on
the floor. A great big guy, now. And he was strong.
Took eight of us to finally subdue him.
But ain't that somethin', just over a piece of cake.

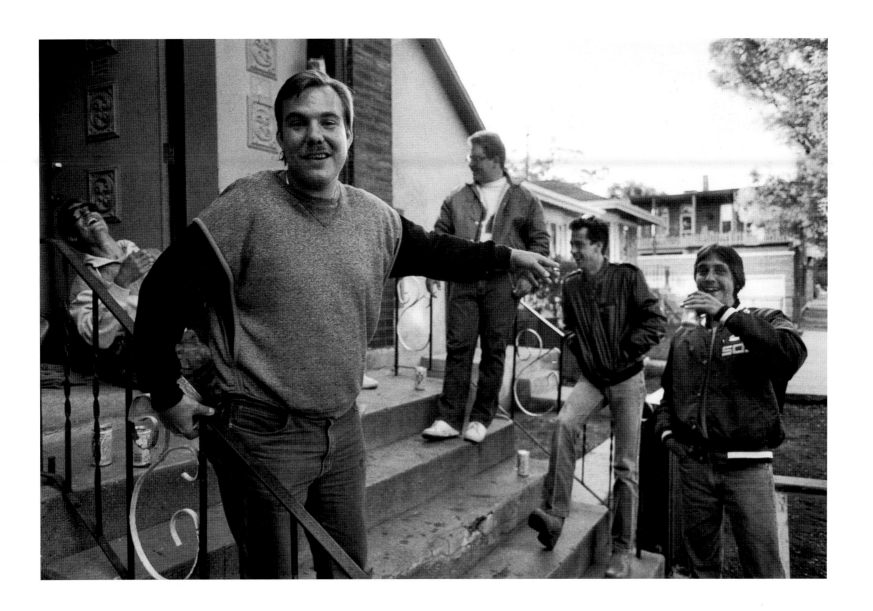

Be Proud

I was born in America, you know. A little town about two miles from the border, called McAllen. In the valley there we were all Mexican, all poor. For the only work they have a white person would ordinarily get paid around $4.00 an hour. But instead they'd get two Mexicans and pay them each half. You see, $2.00 an hour times two is $4.00.

And now I find in my job in Chicago the prejudice is very bad. The whites don't speak to none of the Mexicans; they don't say nothing to them at all. The first morning I come in, I'm polite, I say good morning to the foreman and everybody else, but they don't say nothing back. So from then on I don't say anything to them either.

A lot of the day I sit around and do nothing. Even though I'm an engineer, trained to fix most machines in the plant. Last month this generator broke down when I happened to be near the area. So I just stand there. See, they never ask me, even when they're confused, which is a lot of the time. I watch 'em take apart the whole thing, then put it back together, but it doesn't work. They strip it down again, look at all the parts and stand around scratching their heads. Still none of them can figure out the problem. Finally one of 'em turns to me and says, "What do you think it is, José?"

I say, "Why don't you tighten this belt a little?" Well, they do it and what do you know! The machine works now. So when I come in the next day the foreman and the other white guys all give me a big "Good morning, José!" like nothing ever happened, we're all big buddies. But I know.

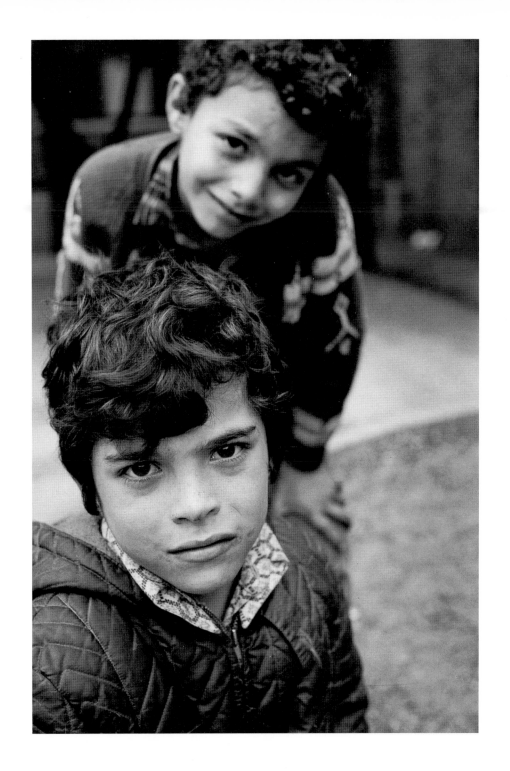

When I first started there, this American, I think he came from some European country, he was supposed to be showing me how the repairs go. But if I had to do this thing first and that third, he would show me to do the third thing first and the first thing last. Of course, from my schooling I knew pretty well what he was doing, but still we have some machines I hadn't seen before. Although I think I could have done everything okay if I just do the opposite of what he tells me. But one day I told him, I said, "John, if the boss asks me to repair something and it doesn't go right, I'm just gonna tell him that I couldn't learn because you been showing me things wrong; you been trying to foul me up on purpose." So after that everything was alright, he respected me.

That's the way it is with those people. You gotta be tough with them. I'm not a fistfighter or nothing like that, but I stand up to people. You have to. Of course, I don't tell my kids about too much of this stuff. What for? Oh, I might tell them a little. But mostly I just tell them to be proud. Be proud of what you are.

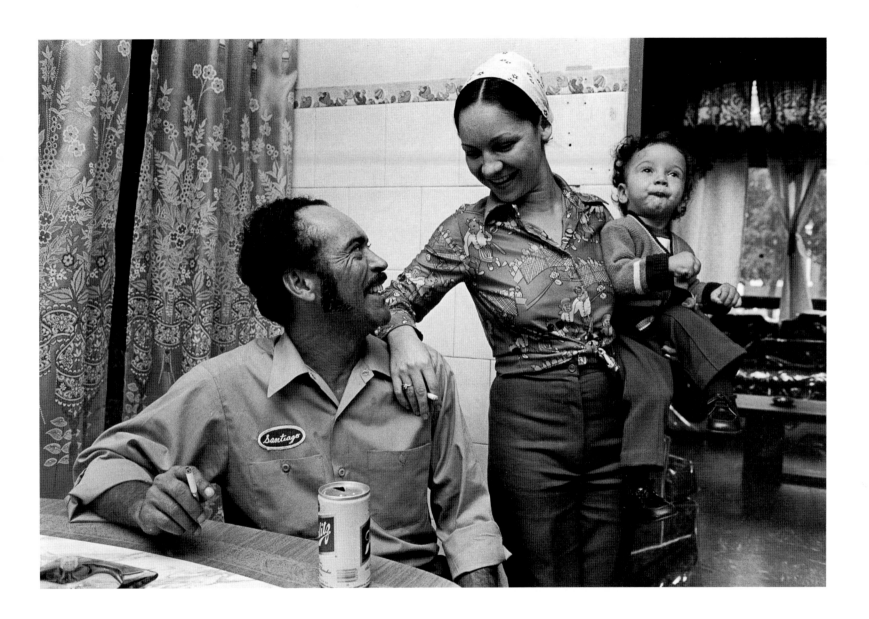

Politicos

Don't think Chicago has a lock on colorful politicos. My home state, Georgia, bows down to none in that department. And you could start with Eugene Talmadge. Law degree from Harvard, speaks as well as anyone. Sharp dresser too. But bein' away at school so long he'd lost touch with the people. Couldn't even win a county election. Sure, the average Joe didn't appreciate all that polish and sophistication.

So first thing he buys him a half dozen suits, right off the rack, that were a couple sizes too large. They hung all rumpled over him. Next, realizing that nobody wanted to listen to a Cicero or Demosthenes, he started talkin' folksy. This was about the time his son, Herman, came along. Now at rallies proud papa'd stand up and introduce him, say, "This is my son, Hummin Tummidge." Hummin Tummidge, say it as if he'd just called the hounds off a hunt or like he'd been drinkin' corn liquor with the boys in back of the garage.

I can still see him stumpin' at the county fairs: wipin' his brow with that big mop of a handkerchief, tuggin' at his suspenders, lettin' on to the common folk how he understood their problems. Bring tears to many a hard man's eyes.

And he'd close every speech—I must have heard hundreds of 'em—with the same words. It was like a trademark with him. Say, "The poah mayun in Jawjuh has three friends in this world: Jesus Christ . . . Sears Roebuck . . . and Eugene Talmadge!"

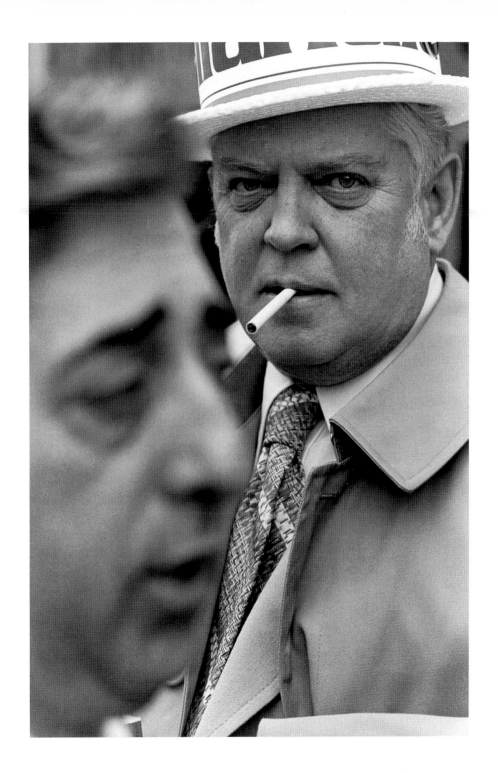

420-to-8 Man

You hear what the judge called me at our fundraiser last night? A 420-to-8 man. Whispered it to the committeeman just before he coughed into his fifty-dollar silk handkerchief. An old 420-to-8 man. That's right, if the opposition gets 15 votes in my precinct it's an upset.

In '58 we carried 409 to 2. I just lose the Republican judges and even they apologize for goin' against me. "What the hell!" I told 'em, "we don't want no investigation out here. Vote your conscience."

Of course, how would they know I could change their ballots on the way to headquarters. Oh, Jesus! we'd take the box home sometimes and mark 'em up. But you had to be real careful with them erasures. That's why it took all night. And then next morning throw down a cup of hot coffee and drive the tallies over to Clark Street. All for the party of justice and mercy.

I mean there I am in '33, dead broke, holes in my shoes, no food in the cupboard—we could have starved—and they took me aboard. Been on the payroll forty-two years. And that's no one-night stand now, Joe, is it?

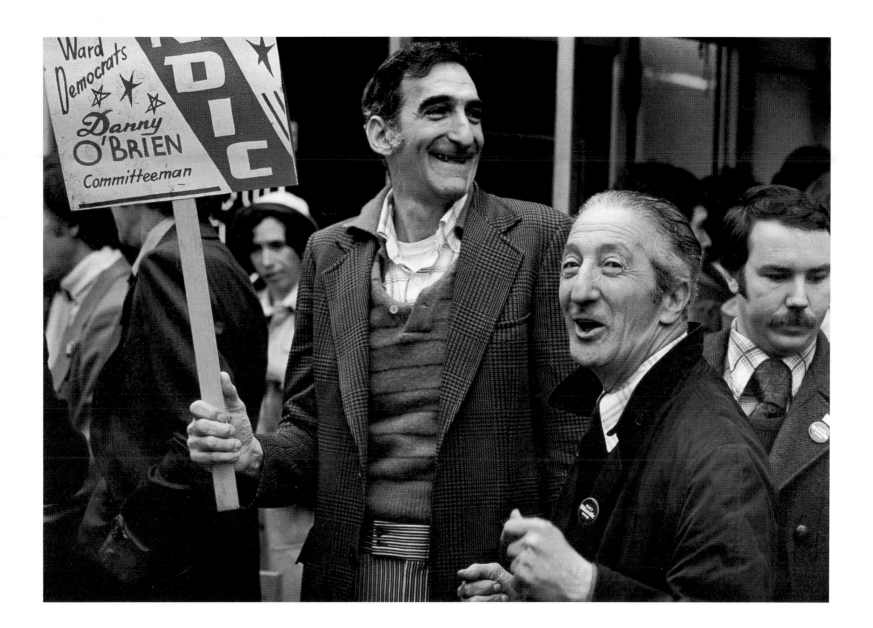

Polish Precinct Captain at Polling Place

Good morning, ma'am. Good day, sir. May I ask
you both a question? You got a car, don't you?
Okay, when you wanna go forward what do
you do? You shift it to the "D," don't you. That's "D"
like Democrat. And so you getting ahead.

But look at when you wanna back it up.
You gotta move it to the "R." "R" standing for
Republican. And what's happening now? Reverse.
You getting farther behind. Don't do that!
Please don't do that.

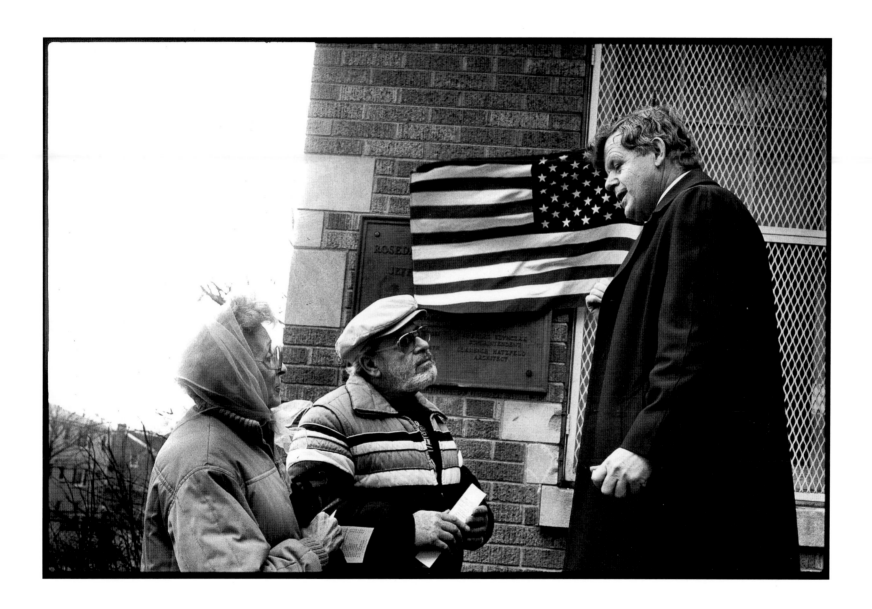

Randolph Street Market Boss

It's all very friendly, like a community. Weekends we
have all the beautiful shoppers, the housewives. One
Saturday a truck driver came in from California and
starts talkin' to one of our lady customers. Next thing
you know they go to City Hall. Get married. After they
know each other one hour! Then they come back and
we throw a party for them right here in this building.

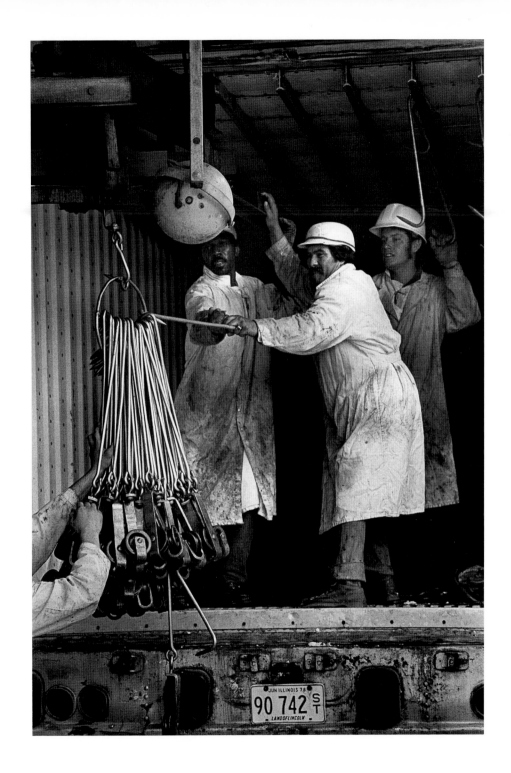

Trucker

Three words I used to hate the most
were "got to work." I've got to go to work.
Eleven o'clock I've got to get some sleep
so I can get up and go to work. Uh-uh.
See, I'll be at work. I'd live the job for two,
three weeks at a stretch. Like shoot to Baton Rouge,
take on a load, and come straight back to Memphis.
Knowin' I couldn't sleep for fifty hours,
that never bothered me.

Waitin' for loads down South I'd miss a day
and fish. You got a frying pan and then
I'd keep a long stick of butter in
the cooler with my emergency rations.
Drive down a side road and maybe catch dinner.
Live off the land. It's like my mother said,
"Truck driver's nothin' but a bum who's got a job."

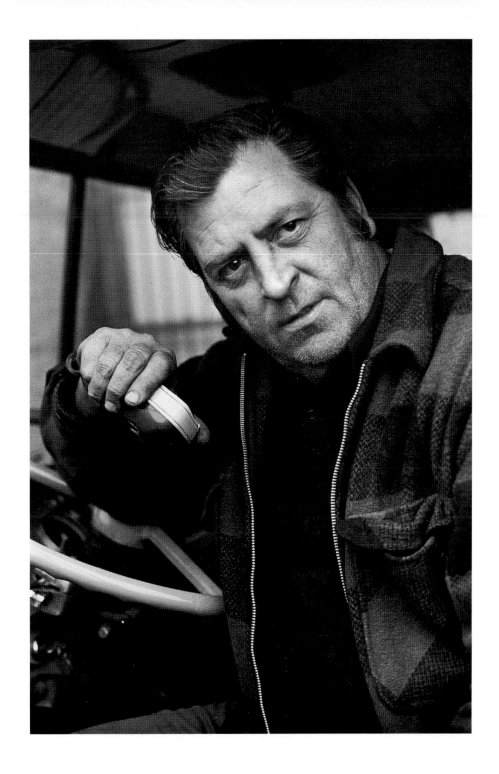

Street Pavers

Don't stand between the machine and the truck!
They had a guy on last year got hit by the pan
and fell underneath the roller. When
Don pulled away he was lying there.
It crushed his chest. Just moved his lips
a little bit, asked for a drink of water, and died.

But I'm like this, see, watching. I'm watching,
I'm watching, I'm watching . . . we watch for each other.

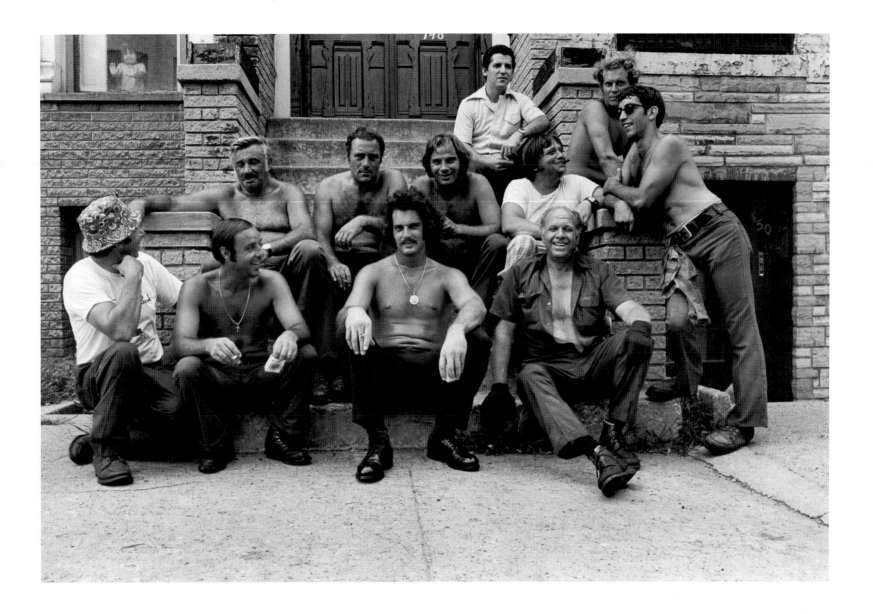

Ship's Cook

I've piloted boats so slow they couldn't get
out of their own way. But this one's a honey.
Twenty-one-hundred horses on her. Engine alone
cost a quarter of a million dollars. On a quiet day
we'll tie on fourteen barges and take 'em over
 to Beth.

But I'll tell you one thing: if you get a good cook
you better pamper the piss out of him. 'Cause
he's worth his weight in gold, you better believe it!
You know the politician Bill O'Connor? His brother,
Jack, used to be our cook. Goddamn good one too!
I mean he kept his galley clean. I
wouldn't be afraid to have my men chow offa
the floor, that's how clean he kept it.
But that guy could cook, and I mean everything.

But there was one thing Jack liked
more than anything else in the world: casino.
With the two of spades and ten of diamonds. If you
played casino with Jack, you'd eat good, man, I swear it.

You know that landfill at Northwestern
University, with the park and the
observatory? We brought all that sand up there.
Worked 'round the clock: fourteen days on, seven
days off. Played a lotta casino on those hauls.
And had steak every night. You better believe it!

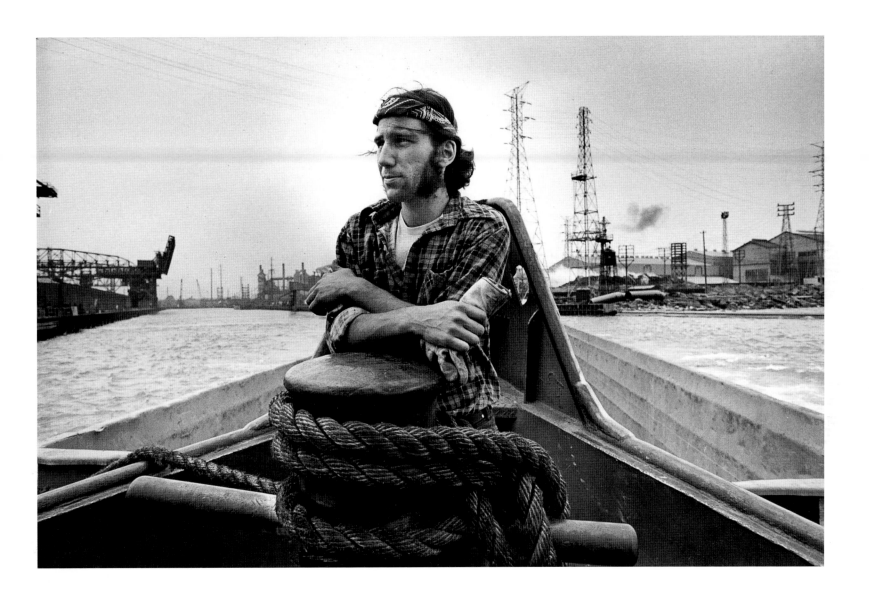

Tying barges together on the Calumet River, May 1976

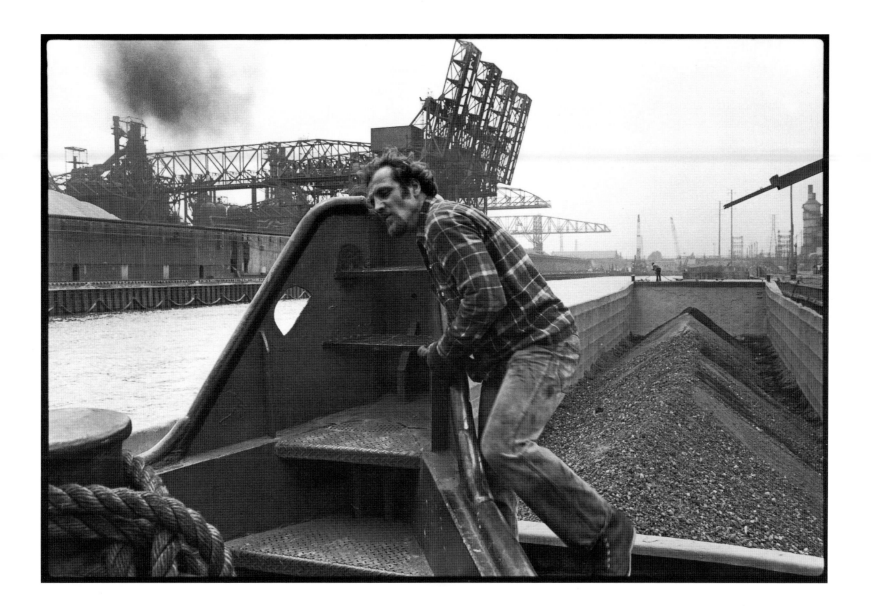

Railbird

The first thing I look for in a horse
is balance. Like that one over there. He's got
a nice, full, rounded ass, but his back slopes up.
His head's held high. That's a very nice horse.

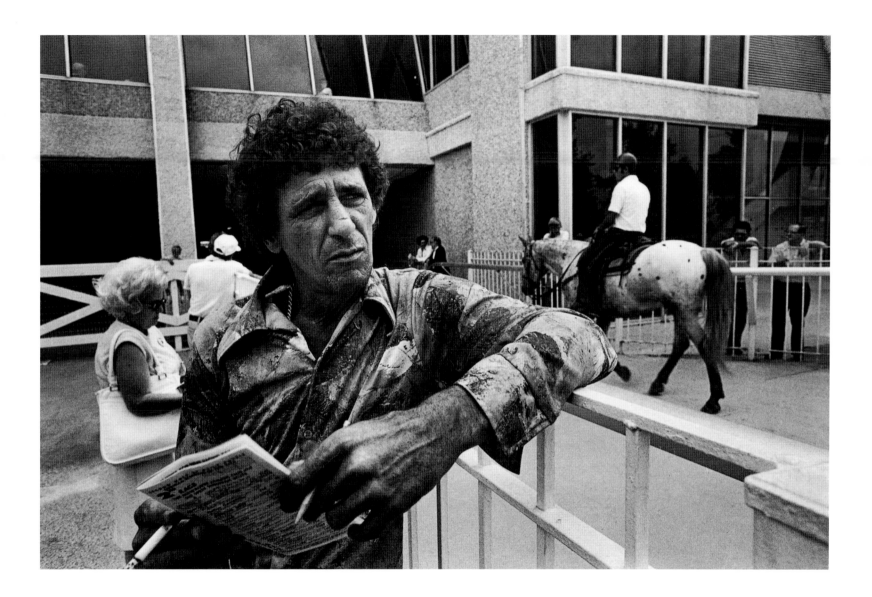

■ ■ ■

And I want a high flesh. His coat should be smooth
and full. Then I know the grooms are taking care
of him. He isn't backing off his feed. I don't
want moisture on his legs. Very bad.
They got him standing up to here in ice water.
That means arthritis or maybe even foundering.

Next I want him big. Even a little fat
won't bother me. Because these horses
not only run a distance, they carry weight
across it. They're not racehorses. Work
animals! Oxen! When I hear a trainer say his horse
is putting on pounds during the campaign . . .

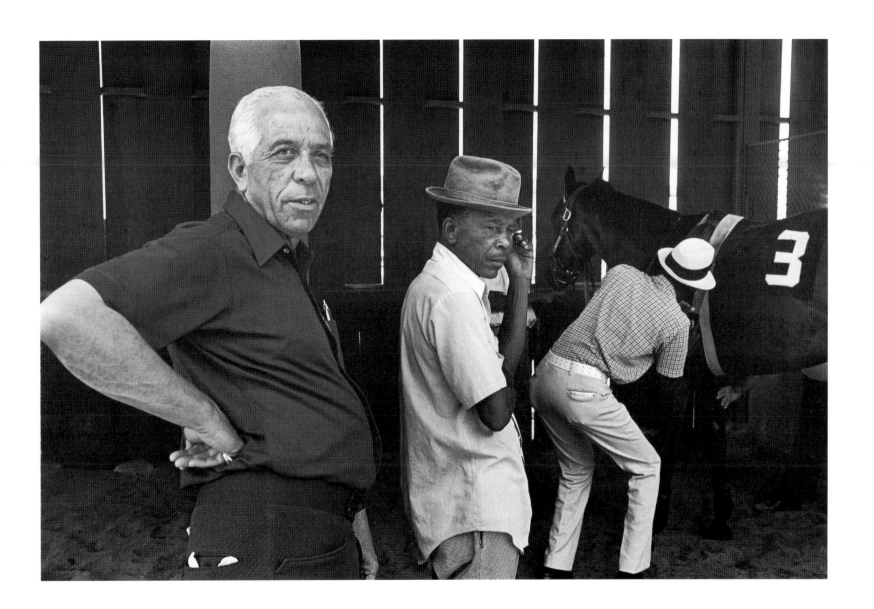

Okay, they're starting . . . look in front . . . you see
my pony's forelegs hit the ground together . . . that's
an athlete . . . money in the bank if he
holds stride . . . let me touch you for luck, babe.

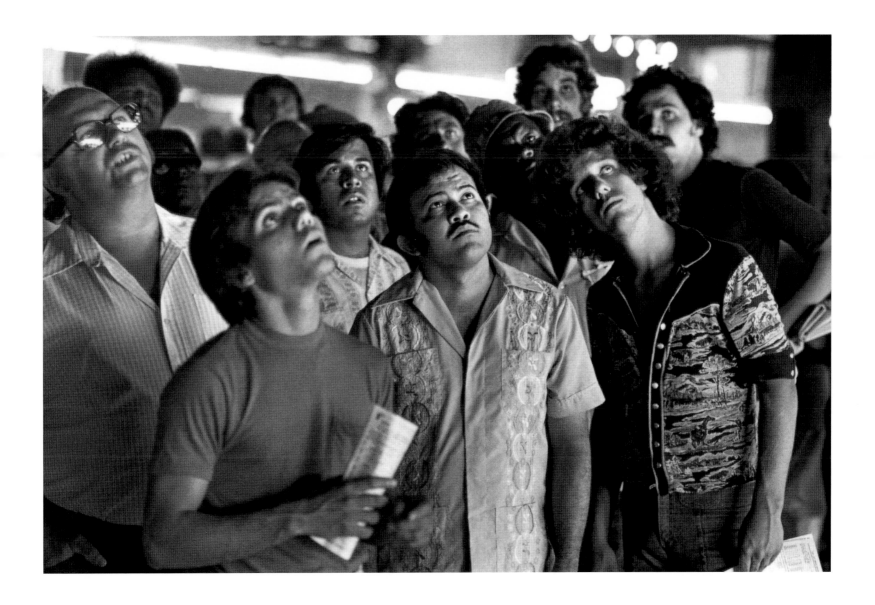

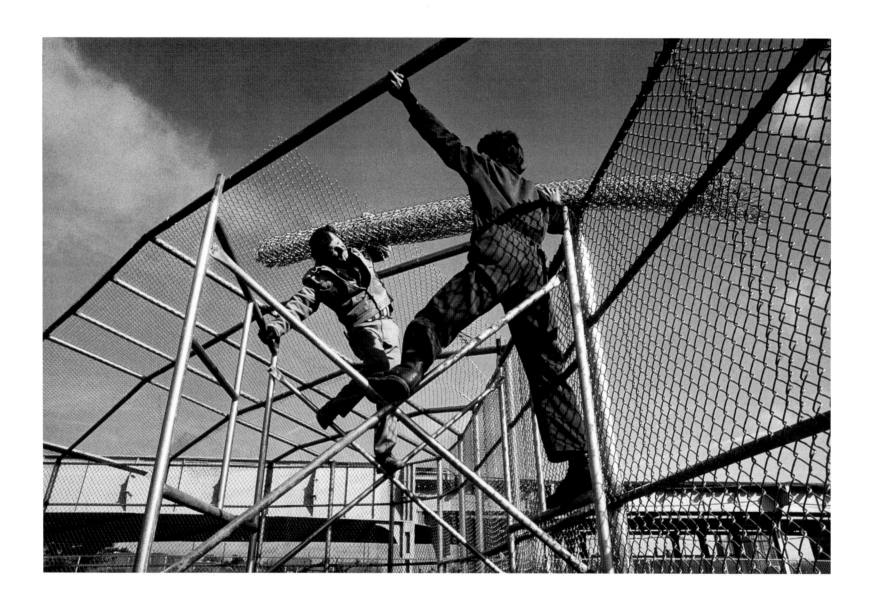

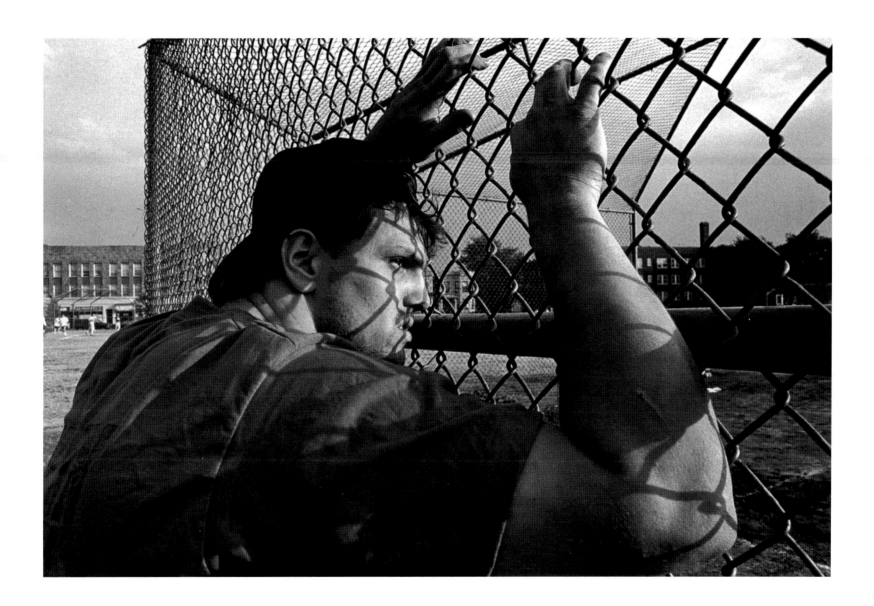

First Romance

That summer I took some college courses downtown.
I always got straight A's, but now,
because of that failed high school romance, my first
(God! did I miss him!), because of that
I only went through the motions. Although I did
quite well anyway. My writing instructor even
encouraged me to send this story to a journal;
he wrote down the address for me. One afternoon,
around five o'clock, I left his class and walked
down Michigan Avenue. I didn't even care
where I was going. I was in a daze. And then
some middle-aged guy, a businessman,
pulled up and offered me a ride.

It was quite hot out.
You could see the pavement shimmering.
I got in with him. His car was air conditioned.
He drove four blocks and stopped at a red light.
We hadn't said a word up to this point. And then
he reached across and put his hand between my legs.

I just looked straight ahead.
I wasn't afraid. I didn't feel anything, in fact.
Then I opened my mouth and words tumbled out.
Someone else spoke them from the back seat,
or they were part of the traffic noise.
Disembodied words. I said, "You can do anything
you want, but it's going to cost you."

Did I say that? Me? Sweet and innocent North
Shore girl? Suburban parents, suburban morals,
knew right from wrong? Was saving herself
until the right boy came along?

He gave me fifty dollars. My first time as a pro.

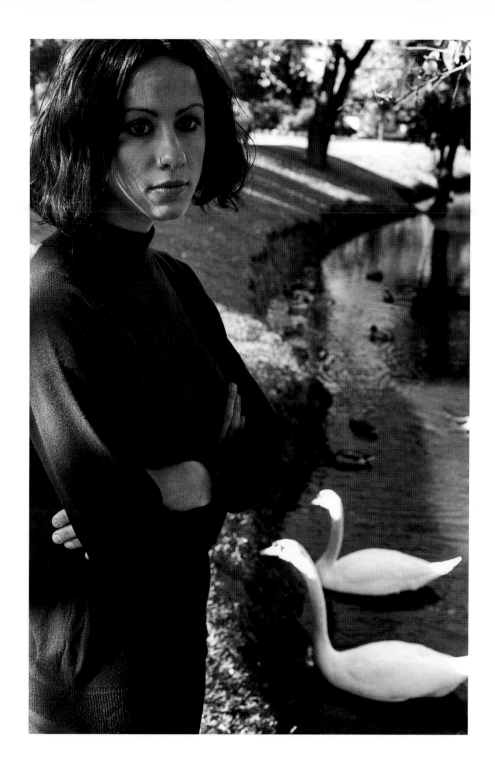

Fruit vendor in Humboldt Park, June 1976

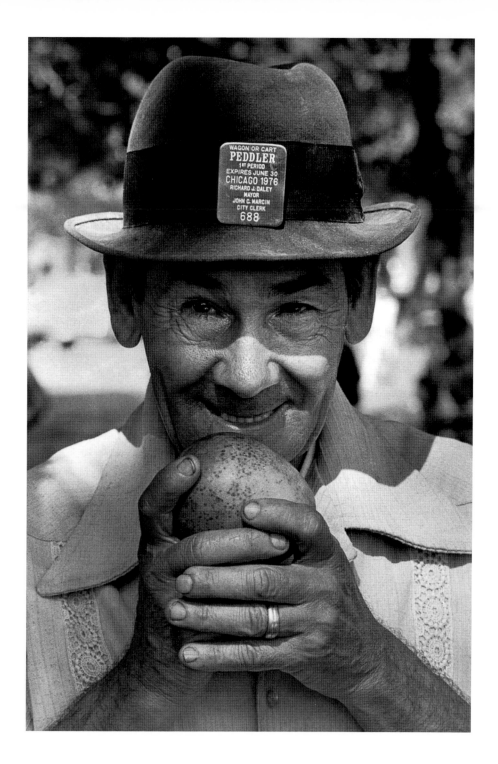

119

Having Kids

To me, I don't see no reason for gettin'
married unless you're gonna have kids.
That's the only reason I'm glad I got married.
Because most of the couples I know don't get
along at all. Maybe for a few years,
maybe, but after that they're not compatible
no more. At least that's the way it is with me
and my husband; we don't have nothin' in common.
The kids are really the only thing.

My husband's an alcoholic. I mean
I don't know how he stays alive even, 'cause
he never eats. Though he goes to work every day!
Just barely, but he goes. I wouldn't mind
so much if he'd just shut up, but no,
he's gotta shoot his mouth off all the time,
always tryin' to pick a fight with me
or one of the kids. I tell them not to argue with him,
 he just gets me obnoxious.
And by and large they leave him alone, except
my oldest. Oh! he can get on your nerves sometimes!
Although I kinda feel sorry for him, he really
hasn't got anybody at all. But mostly
I just try to avoid him, I try to keep busy.

Like I have my garden to take care of—
you should see it now with all the roses comin' up—
and I work, and of course I love to decorate.
I got the whole house painted, and next
I'm startin' with the tiles in all the bathrooms.
You think my husband appreciates any of
that stuff? You got to be kidding! No way!
He just goes into a coma every night
with the drinkin'. Yeah, it seems like all the World
War II guys, they can't leave that bottle alone.

I think I told you we bought some land
in Michigan where I was raised, and we're
supposed to go up there and live next May,
but I don't wanna be alone with him.
Unless he changes quite a bit. You know,
I was voted most likely to succeed,
not most likely TO, if you know what I mean,
in my high school class. Yeah. I was homecoming
queen and everything. And now I'm goin' back
with just a black cat and an old boozie.

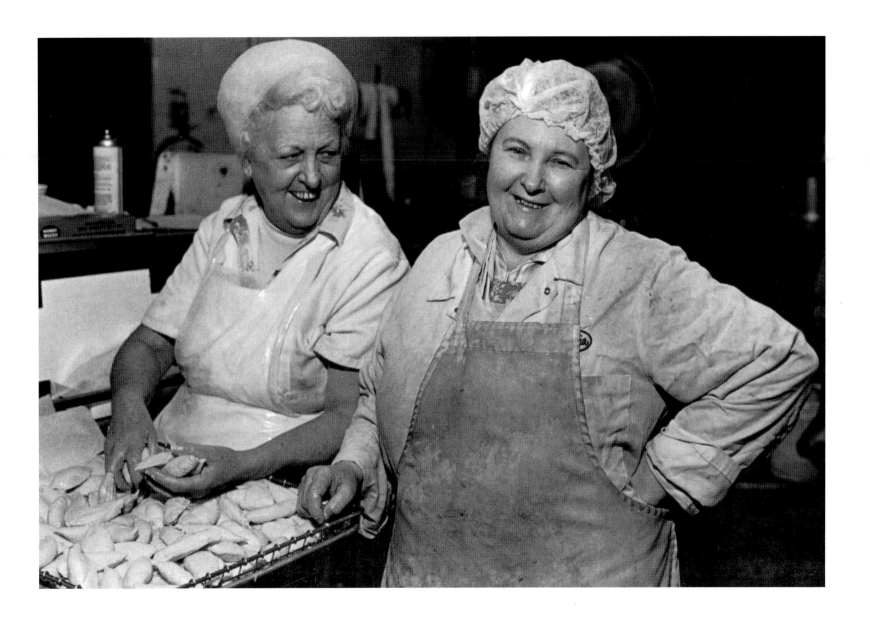

Polonez dancers perform at 5835 West Diversey,
April 1989

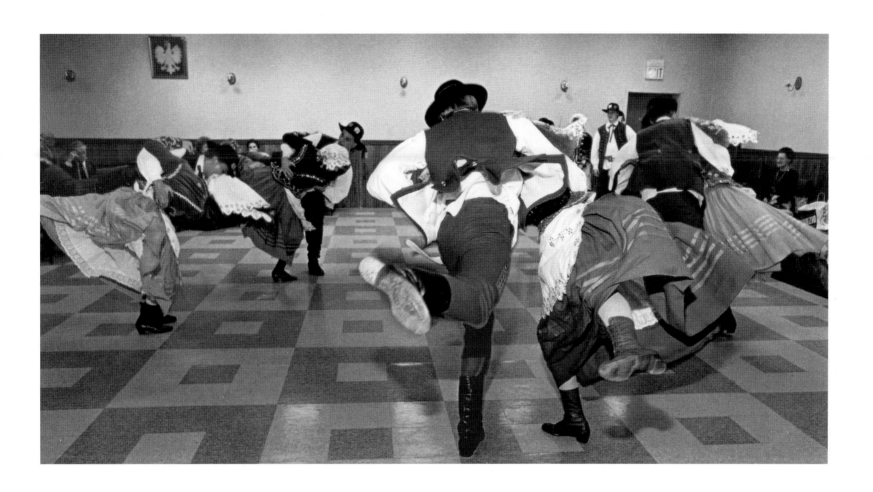

Cabbie

Me 'n' my old lady been together
twenty-two years. Now she's not beautiful,
won't turn no heads when she walks down the street.
But she has a nice body. A big body. I like
a woman with a big body. I'm a big man
and she's a big woman; we go well together.
She's nice, too, and fun to be around.
See, we lovers AND we friends.

Now this buddy of mine, I've known him
since high school, he likes the young women.
He been runnin' around with this gal,
she's twenty-nine years old, he's sixty.
He gotta take her to the nightclub
two, three times a week, buy her all kind
expensive clothes. And then they went out to
the showroom Christmas Eve to pick her out
　　a brand new ride.

I see him with his lady now. And she is
attractive. She has a gorgeous face. But I ask myself,
Just who's he trying to impress? And does
he really like her? More to the point, does she really
like him? Or how long will she stay home
and watch TV the nights he's too beat to go
out cabareting? It ain't none of my business, see, I
just say at my age I don't need the aggravation.

My wife's the only thing that keeps me out
on these streets. Weren't for her I would have shut off
this meter a long time ago. But at fifty-six
what else 'm I gonna do? I'm stuck. Every day
twelve hours of fightin' traffic, duckin' the pOlice.
Ain't nothin' I can't handle, but quittin' time
you walk in the house, fall back on the sofa, put up
your feet, look down and find you got a drink
　　in both hands.

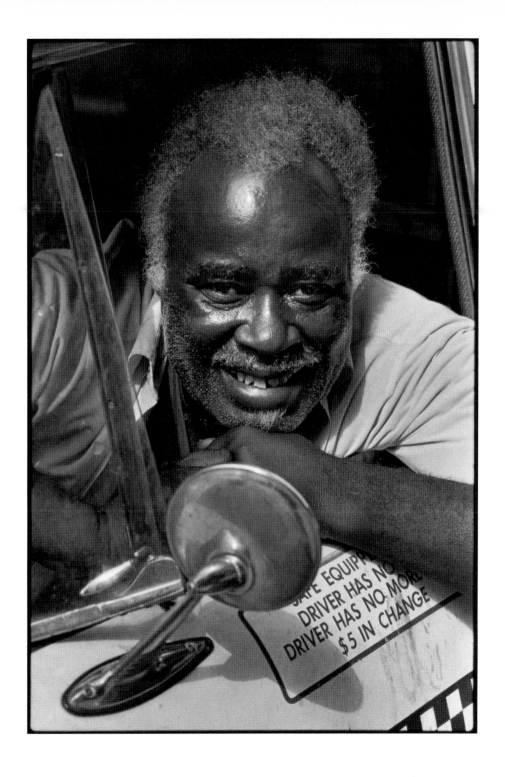

SAFE EQUIPP
DRIVER HAS NO
DRIVER HAS NO MORE
$5 IN CHANGE

Polish wedding, 4808 South Archer, April 1989

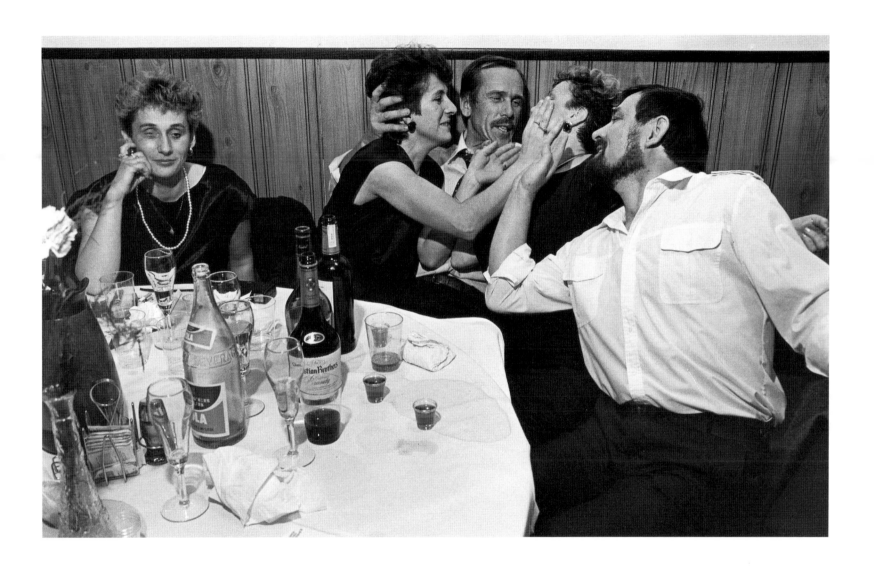

Motorcycle gang getting tattoos on Belmont,
November 1977

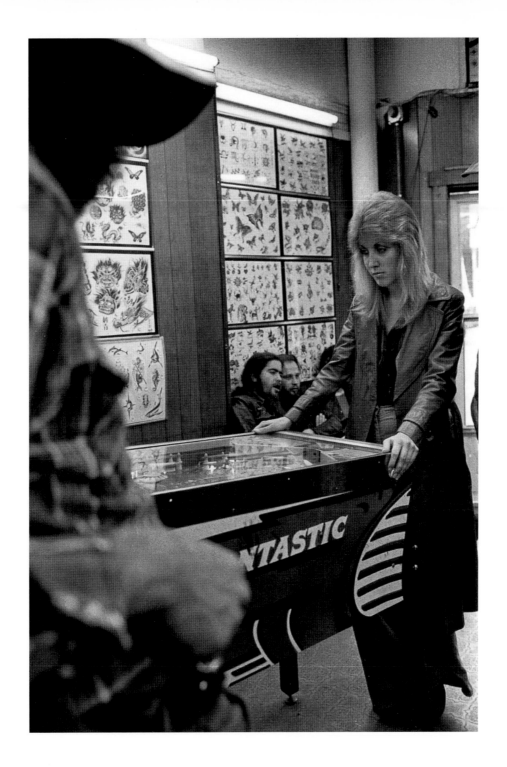

A Jug and a Pack of Smokes

Been sittin' on this bench since none o'clock.
This wine ain't got no kick to it. Just makes
you feel dizzy. I only had a dollar
eighty-five this morning, couldn't afford no whiskey.

We used to sneak across to Mexico. Juarez.
Shack up, you know. You ever been to Mexico?
Better not go alone, or if you do,
you better get yourself together. They'll throw
you in the jug first thing. And then the judge
'll go evaluate your car. And that's a known fact.

I got a dollar forty-one now with
the quarter that you give me. I think I'll go get
a jug and a pack of smokes, although
this port won't pick you up none, know what I mean?

I 'as sleepin' in a hallway just yesterday,
couple police come in and say, "Get out
of here, you Irish prick!" Now what they wan-
na call me that for? I ain't done nothin'.

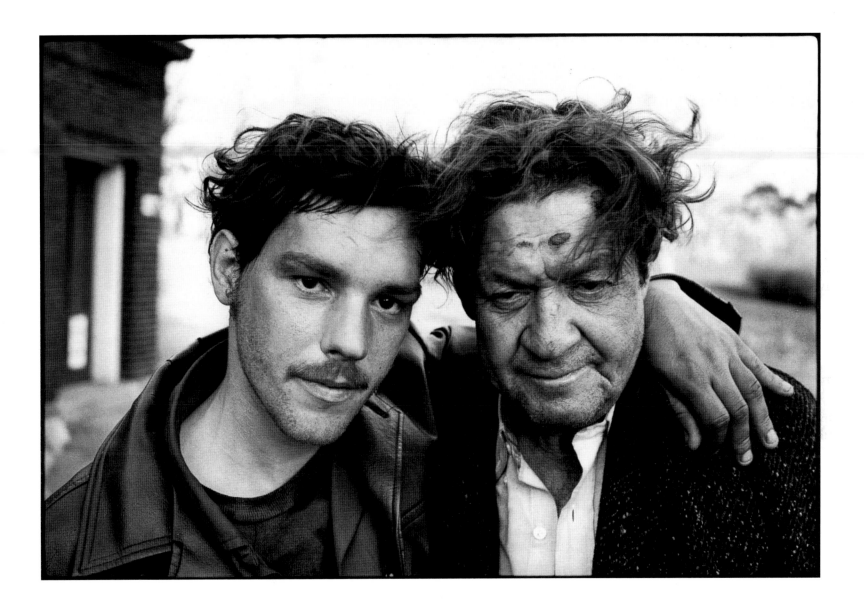

Scavenger

A lot of people say, "Cochise, how
you end up here, out on these streets?"
'Cause, hell! I can do a lot of things! I been
a journey . . . MASter carpenter.
Lay bricks. Do anything that has to do
with paving a road or raising a building.
But, see, my wife divorce me. One day I walk
into the house and there's a man sittin' on
the sofa . . . eating MY food, offa MY plates,
feet up on MY table . . . hmmmph! And then
she say I gotta give her so much every month.
And got a lawyer to back her up.
There's a deposition out on me right now,
says anything I make go back to her.

So I live free. Ain't got nothing to take, but
I got a whole lot to give. Oh, you'd be surprised
the things rich people throw away! In perfect
working order. Radios . . . toasters . . . CLOTHES.
I got my means of locomotion off
a garbage pile. An' didn't have a scuff!
I put 'em on, they squeak just like they s'posed
to when you take 'em out of the shoe box. FREEE!

They even had a private eye, inVEStigator
from the IRS, you dig, come out to watch
my operation. He sees me with my cans and shit.
"Cochise," he says, "why don't you get a job
and find a decent place to stay? This ain't
no way to treat yourself." Hell! I know
every nickel Uncle Sam don't take, him and
my wife'll put in their pockets. Uh-HUH!
Not mine! 'Cause if all I got's the clothes
on my back, 'nough change
for a polish or a pint of vodka (don't
be callin' me no wino now . . . certified
alcoholic), if all I got's subSIStence,
what can the lawyer or my wife take out of that?
No dice! No cash, no stash, no
change . . . noTHIIIIIIING!

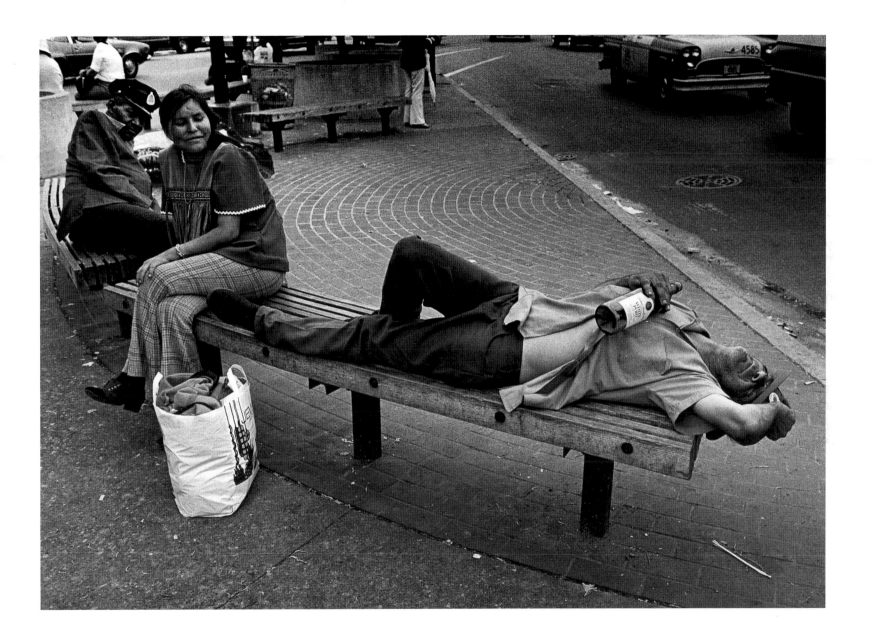

"You need a drink."

ART: You need a drink, Bob?
BOB: No I don't . . . but I will.

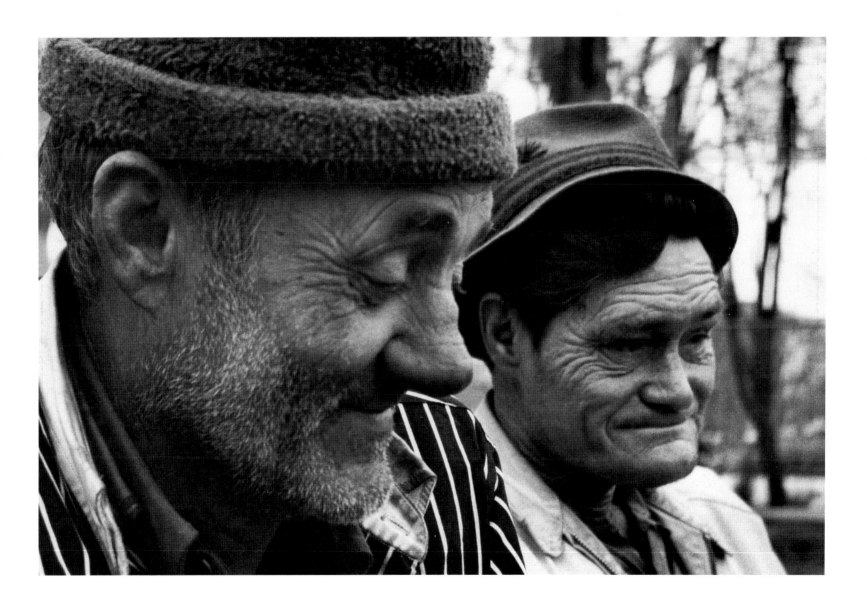

Street Talk

You may not know this, see, but a alcoholic
never hurt nobody. Harmless. We're mellow people, man.
But a dope fiend is something else. Look out!

But we all friends out here. I got a white
friend. I call him honkey-donkey, he calls
me nigger. 'Cause we friends. Don't nobody care
about color. Only color we think
about's the color of the wine. Ain't that right,
brother? This John, th' only white alcoholic on
the street. Gimme a cigarette there, John.

Ain't that right what I been tellin' him, John?
Alcoholic never hurt a flea.
No, no, okay, a blackout then he ain't himself.
Like me or John get sick, instead of goin' to
a hospital or have a wife who tends to us
at home, we might lay down in the middle of
the street here. Alright . . . and that's a death bed.

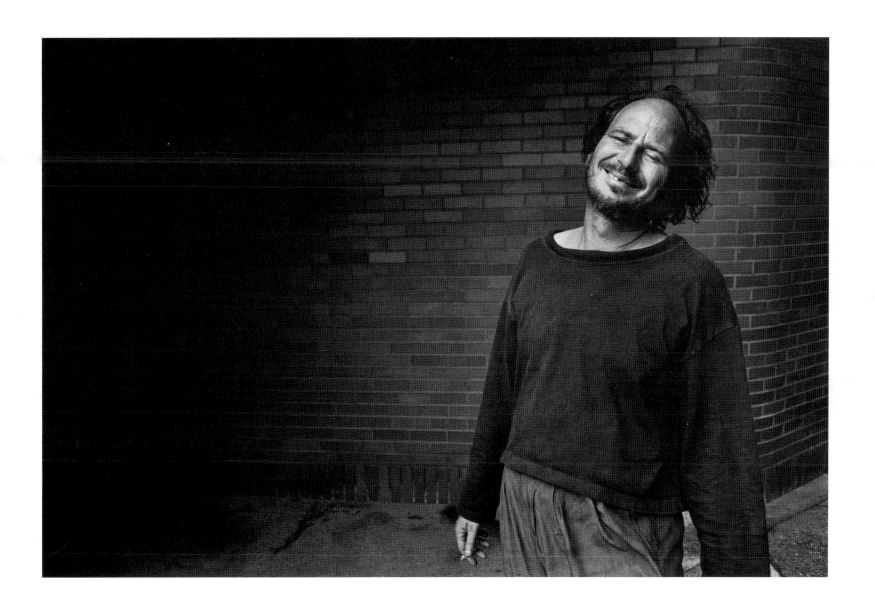

Homeless man at 2600 North Clark, November 1985

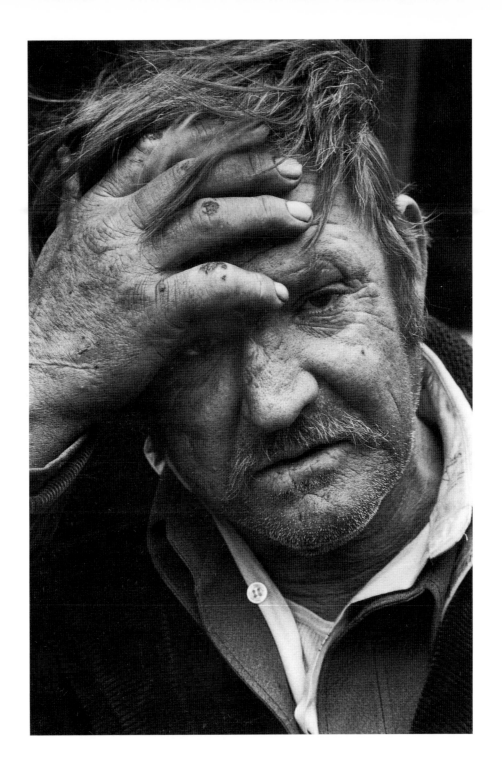

Thumbnail Sketch

I'll give you a thumbnail sketch of Artie.
Alright, he's a hustler, you know that.
Lays low until there's money on the table.
But how well can he do in the local poolroom here
where everybody knows how good he is? And so
he's got to ride the circuit so to speak.
He's got to play the strange towns, the small towns,
walk into rooms where there are guys who'll break
his fingers if they think he hustled them.
That takes a lot of guts. And Artie doesn't have 'em.
(There's nothing wrong with that. You don't.
Neither do I, I'm too old.)

Okay, now he's makin' a little book,
he's takin' some bets on the side.
Doin' pretty good too. But not too good. Oh no.
Who do you think runs these off-track betting joints?
Not independents like you or I, Dick. Of course.
First day these two big guys walk through the door:
"We wanna talk to the owner." Wham! Bam!
The BACK of the hand, the SLAP of the hand!
"And you better not open tomorrow neither."

So that's Artie Dabramowicz . . .
and did you know that he can't read or write?

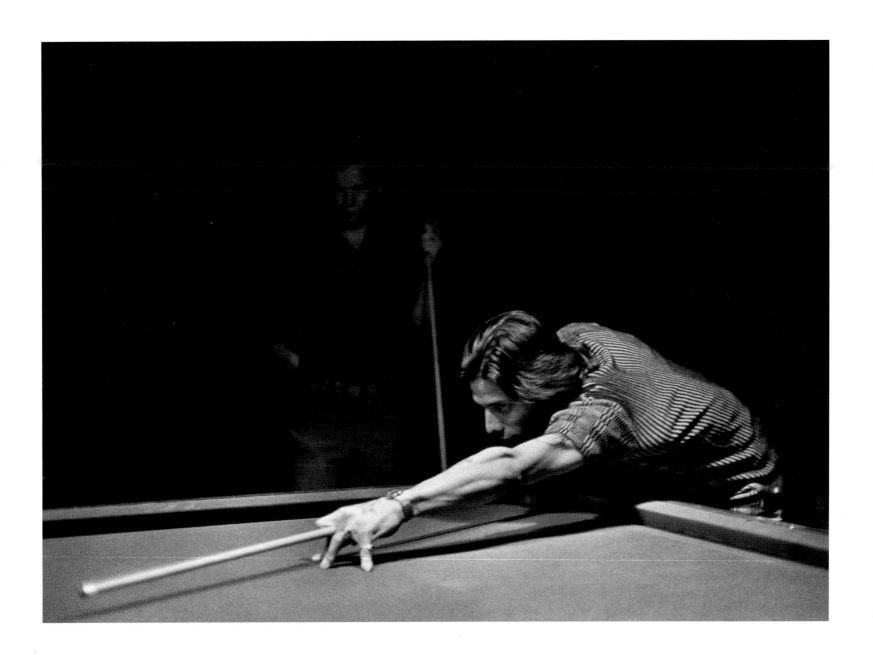

A Gentleman's Game

You see, billiards is a gentleman's game:
"How do you do, sir?" Sir! In pool
it's, "Ah, you son of a bitch!"
Proprietor says, "Sudakis, you think
you could watch the language, uh, there's
a lady present?" "Aw, go fuck yourself!"
Now how can you take your wife to a place like that!

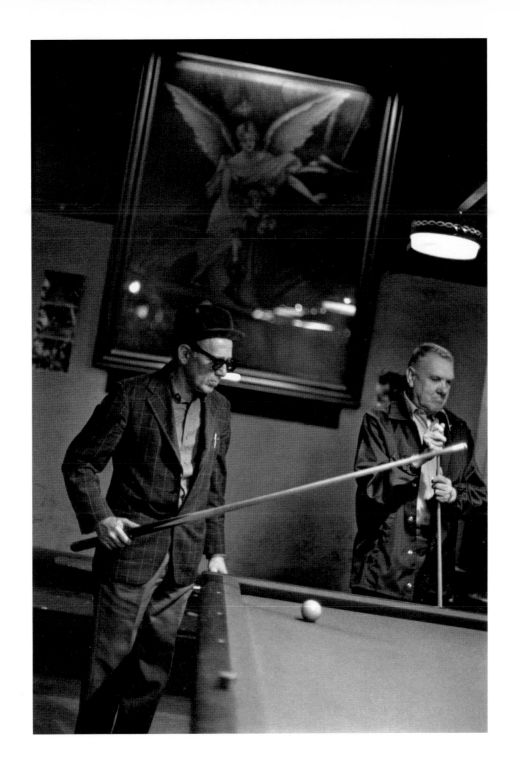

Signals

It sure was a lot more interesting before
they put in their "communications."
We used to be able to say almost anything by gesture.
Take numbers: for one you just clap once, for two
it's twice, five was a fist, and if
you touched your belt, the elbows out, why that
was eight. Reclining, see? Locations too.
To send a hogger to the pocket, say,
first motion him away, then brush the side
of your pants. You touch your pocket. For
the icehouse, get him goin' again, and blow into
your hands, like when it's cold outside. Oh yeah,
we had a lot of fun with all our signals!
Back then. But now you switch on
the radio, "one forty-seven, shove
'em in the clear!" A lot of static too.

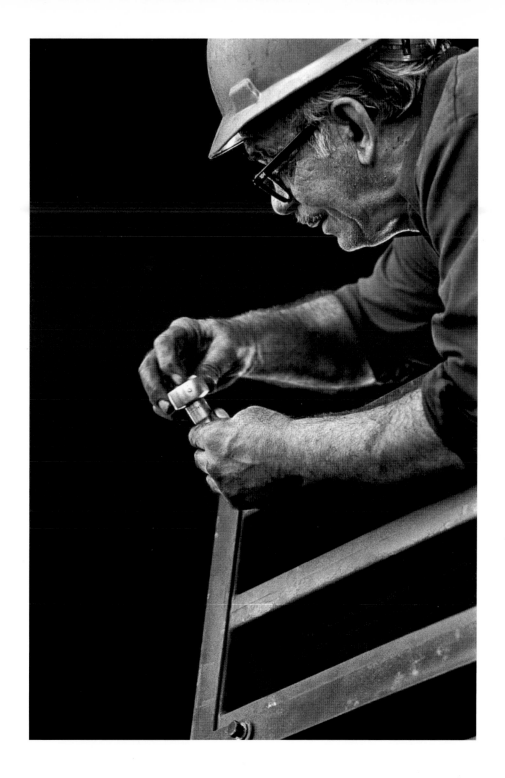

Yardmaster

You know I just can't understand people that don't like
their work. How can someone get out of bed every morning
and go to something they hate? Because
I get a bang out of this job. Mmmhmm.
Yeah, me and the railroad get along real well.
I do the work and they pay me. Plus I get good benefits.

But it'd be hard explaining this to an outsider.
Well, take my next-door neighbor. He's got a
big model train setup in his basement, probably
ten thousand dollars worth of equipment. It takes
up the whole area. Now he'll go down there and spend
a weekend, hardly see his wife and children
for forty-eight hours straight. Just like an overgrown kid.

Oh, he's got everything: switch engines, sidings,
waycars, covered hoppers, the works. And that's fine.
For him. But I don't need it. Uh-uh. You know why?
Because I've got the real thing, right out here in the yard.

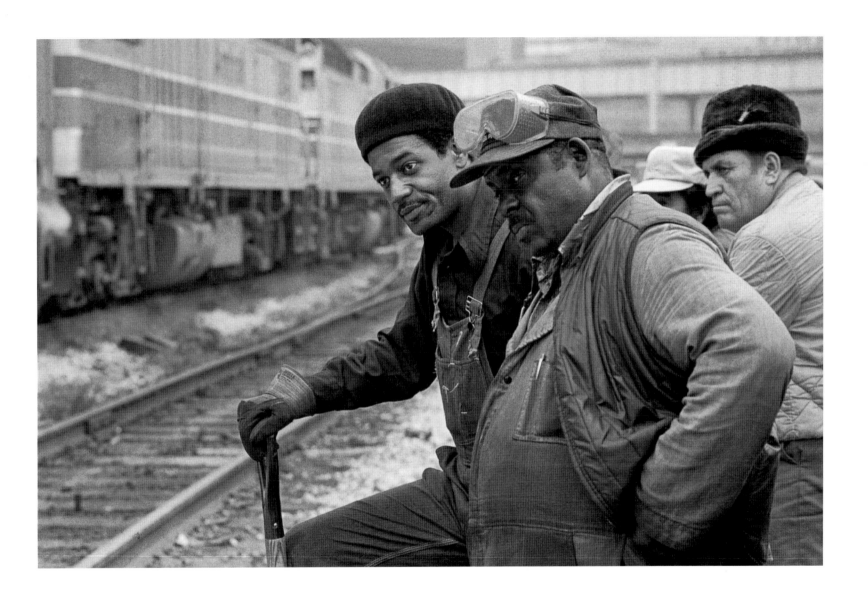

Gandy dancer, Randolph and Canal, November 1973

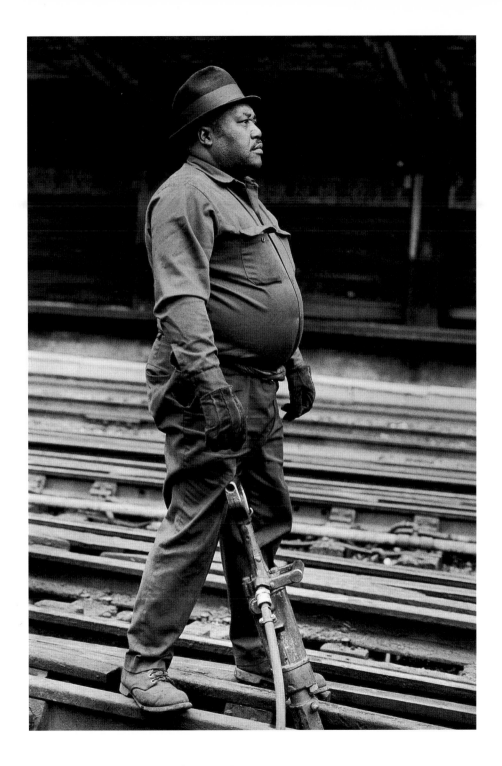

Steam Engine

When I come on in '48
I fired for this big Italian fellow
with one of them handlebar mustaches.
Oh, he run a tight ship, no questions asked.
Report a half hour early on his crew;
sweep the floor, every cinder, ash, and bit
of dust, polish the windows, and rub
them grab rails 'til they shone!

Back then you dressed like railroaders too.
Everybody wore the coveralls,
and you remember them red bandanas?
They kept the cinders from falling down our shirts.
Scorch you! So before boarding the train,
we'd take the kerchief, tie it tight around
our necks and fasten it with a safety pin.
That was the dress code. Now this here I got on
is casual, I'd wear it to the bowling alley.
See, you don't even get dirty on the job no more!

And the diesels that we got today is like
drivin' a car almost. Nothin' to it.
But not the steamers. No sir! Like takin' that seven-
mile stretch of hill goin' into Milwaukee. You couldn't
just glide up to it. Had to take it real easy:
Kah-chug, Kah-chug, Kaaah-chug. Although on level ground
there was nothin' stronger. Why, you tie
the Rocky Mountains to an old S2, say, it'd haul
'em right into the Rio Grande. Huh! Like
a draft horse pullin' a kiddy wagon.

But uphill that was the best them pistons could do.
Kah-chug, kah-chug, we'd throttle down—whoosh—just
over the line, kaaah-chug, through all seven miles of grade.
Oh, it was a thing of real beauty!

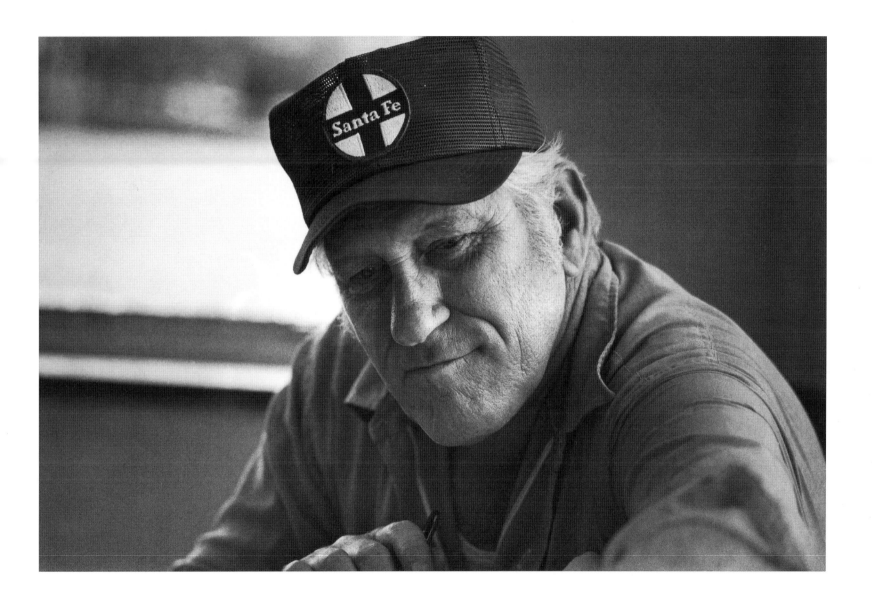

Watch Repairman

I grew up on the North Side. My parents were both
from the old country, and even though I was born in
Chicago I only spoke German until the age of five.
Funny thing, you could walk through entire neigh-
borhoods, certainly ours, and never hear a word
of English.

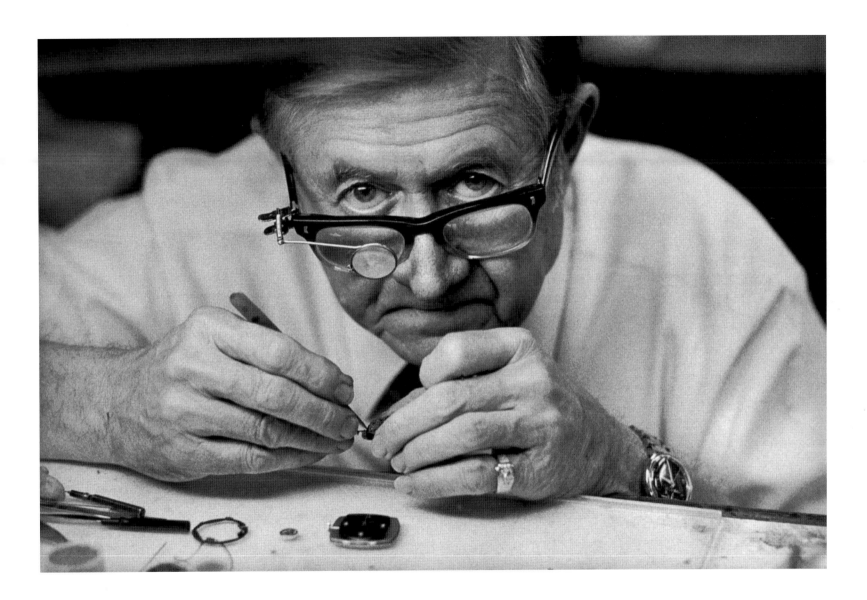

Young girl on the steps of the Cultural Center,
Randolph and Michigan, June 1997

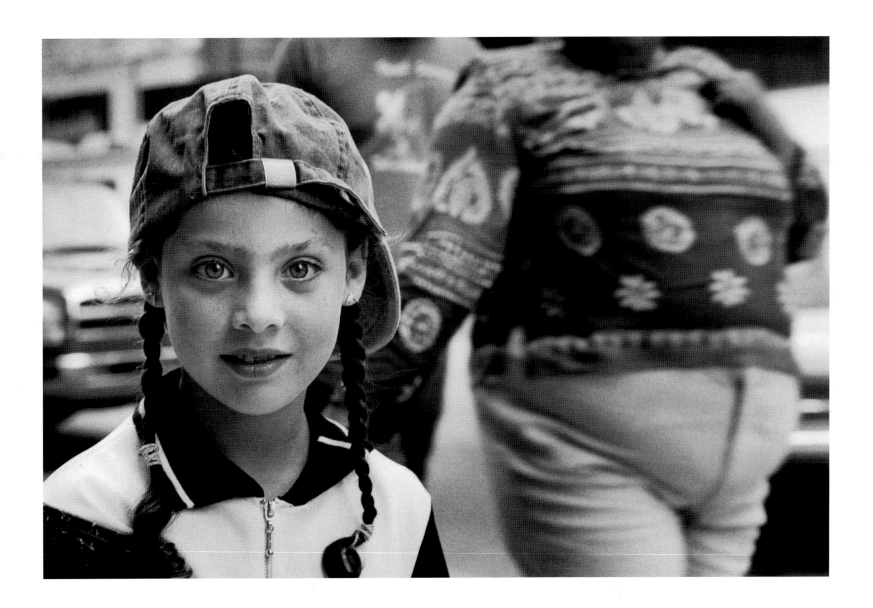

Little League (T-ball) player at Welles Park,
4500 North Lincoln, June 1995

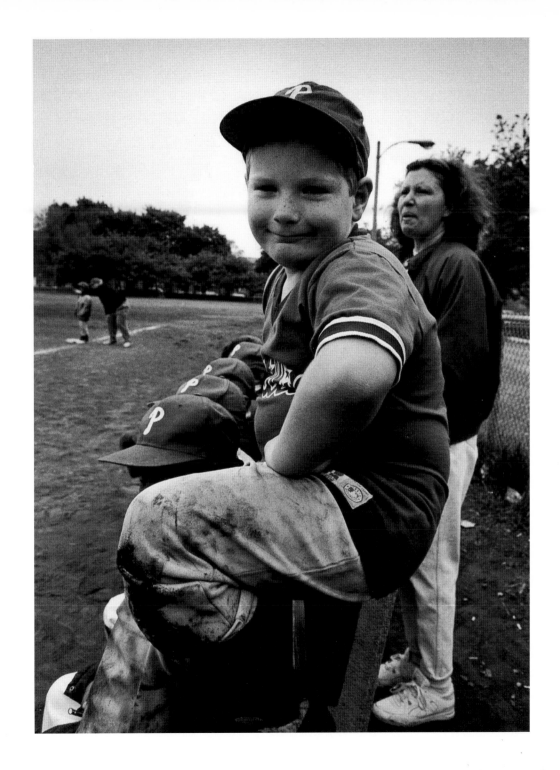

Child playing on the 4500 block of North Beacon,
June 1977

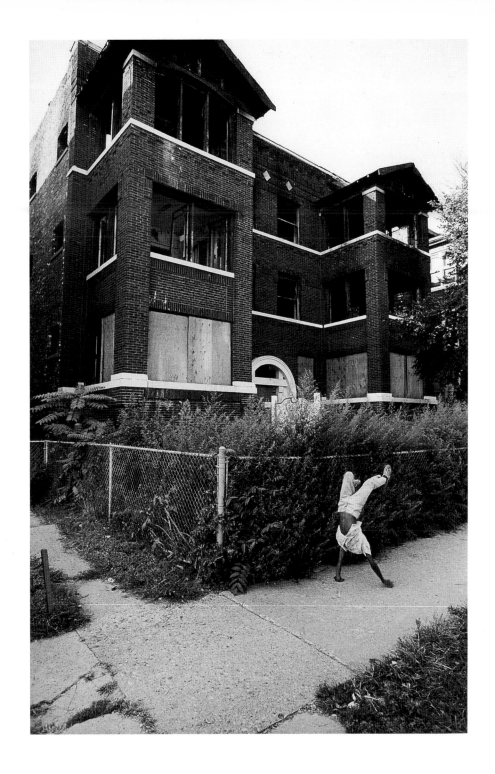

Fight No More

Beega feesh I catch Lake Meechegan,
he thirty-nine-a pound. What a fight
he make. My bobber go op
and down, op and down, then zeep . . . she skating off
across the water. I start to reel 'im in,
I pool, I pool, but ain't a-gonna let me.
He strrronga. I set the line on drag, but steel
he pool. BEEEG and strong. After half
an hour he comin' back to shore, my arm
a-shakin'. BOOM! he jump straight
out water, land on dock. Once he flop sprayin' a-
water over me, lay steel.
I gonna seet on him, but then look down.
"No, I ain't a-gonna fight no more," he say.

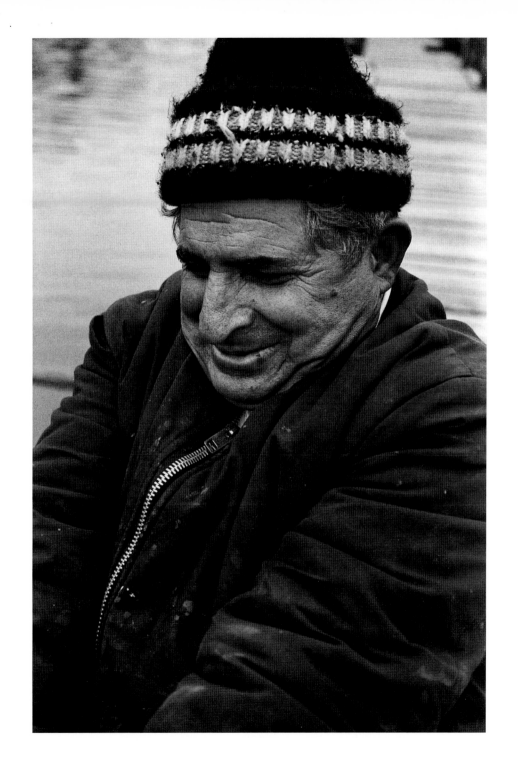

Reminiscences

I knew Billy Sunday. You know he used to be
a ballplayer. Played for the Cubs, only they called
'em something else back then. And for
a while there he was a down-and-outer. That's right,
we had a tailor shop and run a little second-
hand store on Harrison. He'd come in and pawn
his clothes, even his shoes sometimes, to buy
a pint of whiskey. Sure, sure. Hung around
so much one time my father called me over,
said, "Abe, here's a dollar, take this fellow to
the mission, and see he gets a place to stay.
'Cause he's driving me crazy!"

You know I grew up next door to Hinky Dink?
The alderman. Him and the other fellow, now what's
his name . . . Bathhouse John. They traded off
every two years in the city council.
You hear of his Workingman's Bar? Why, he
had the riffraff from all over the city sleeping in
that place, every kind of tramp imaginable.
Fed 'em real good, see. Then six
o'clock election day, they'd throw a string
of firecrackers in the basement there.

Now I remember they had them great big schooners with
the thick bottoms, real heavy. And Jesus! you had
to watch out in there! Sure! Why, anytime
you turned your head another bum'd grab your glass!

You ever hear of the Yellow Kid? The celebrated
Yellow Kid Weil. Did I know him! We were like this!

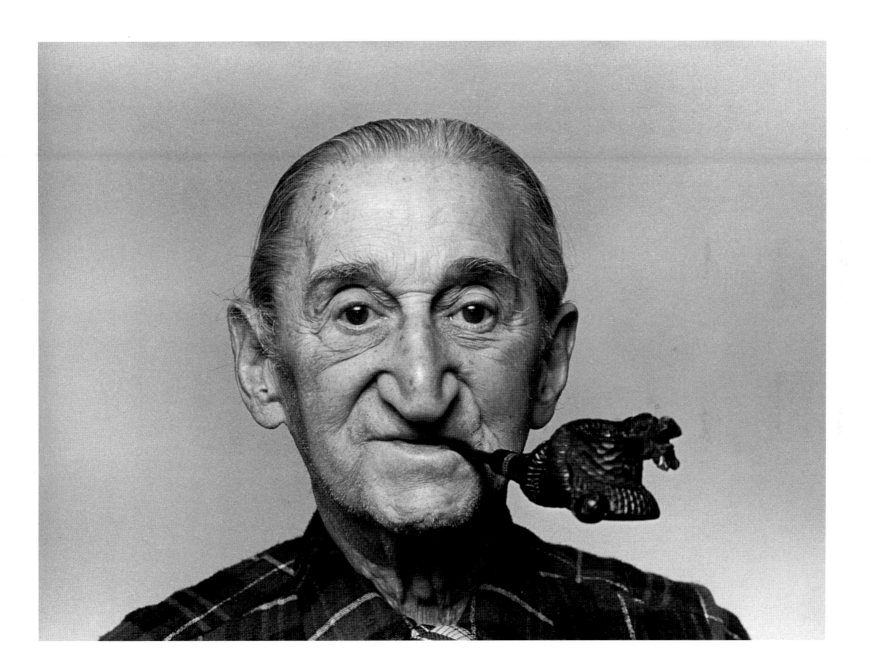

Industrial Sunset

Suppose the sun's a giant wrecking ball,
a globe of molten steel, that pulling outwards snaps
its wire. Untethered, plummets soundlessly
into some unseen pit or quarry, and burrowing,
kicks up a hundred billion pounds of burning dust.

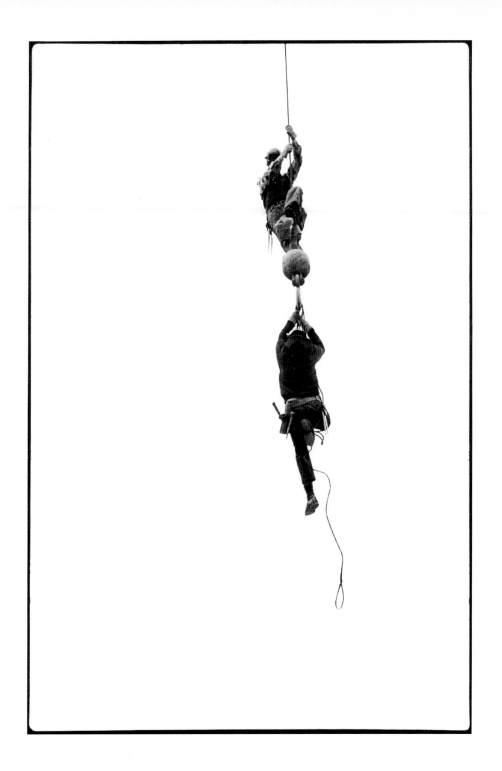

Ironworker at the end of the day after erecting a
construction crane, September 1978

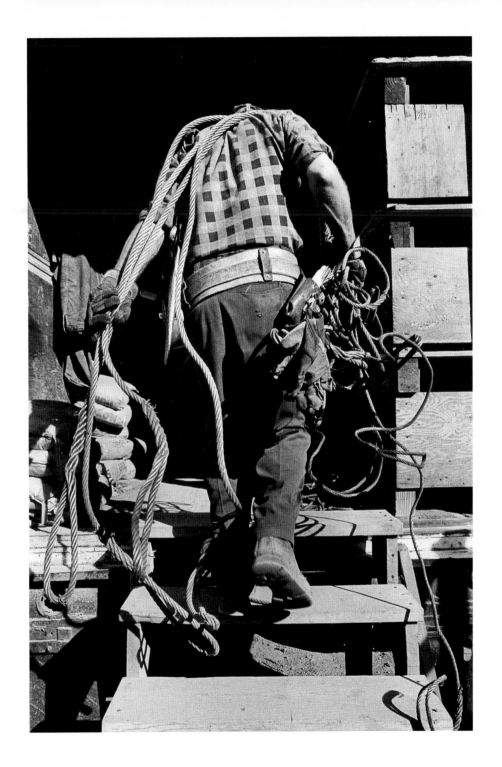

A Line of Credit (with a Brooklyn Accent)

You need a fresh start. I can tell that just
by lookin' at you. Young fella, good lookin',
wearin' last year's clothes. Survivin' from paycheck
to paycheck, ain'tcha? You need to make
a presentation. Jump-start yourself. Let's see,
you got any credit cards or anything? No?
Okay, first thing you do is call the Jewel,
say, "Mister Simmons, I been shoppin' in your
establishment the past few months, and I must say I
appreciate the selection you got there.
Matter of fact, I been thinkin' of openin'
a line of credit, and I wonder if
you could explain the features of your program?"
See, it's like you don't need them, they need YOU!
"Oh no, not over the phone, Mister Simmons," tell him,
"maybe we could talk in your office, oh,
next week sometime." Don't rush the guy, see.
Maybe he got beat with some bad paper
last month; he still could be a little touchy.

So you get your plastic and after a couple months'
good citizenship, payin' off those ten dollars,
overextend yourself for five, six hundred. Meantime
you bought a new car for two hundred down,
a couple suits, a stereo on credit,
which is like an insurance policy, because everybody
and his brother has to have one.
So that's the inventory. And then one day
throw everything in the trunk of your car, get in,
turn the ignition . . . and BLOW for Los Angeles!
There! Now you really got something!

Richard Younker was born in Chicago and attended the University of Chicago, where he received a bachelor's degree in psychology. He has been employed as a mailman, sixth-grade teacher, encyclopedia salesman, public aid caseworker, employment counselor, actor, and singer. As a photojournalist for the past twenty-seven years, he has contributed forty photo-essays to the *Chicago Sun-Times* and the *Chicago Tribune* as well as to the *Chicago Reader*. His books include *On Site* (Thomas Y. Crowell, 1980), *Street Signs Chicago* (Chicago Review Press, 1981), *Our Chicago* (Chicago Review Press, 1987), and *Yankin' and Liftin' Their Whole Lives* (Southern Illinois University Press, 2000).

Composed in 9/14 Helvetica Neue Extended

with Helvetica Neue Extended display

by Barbara Evans

at the University of Illinois Press

Designed by Paula Newcomb

Manufactured in China by Everbest Printing Company

through Four Colour Imports, Louisville, Kentucky

University of Illinois Press

1325 South Oak Street

Champaign, IL 61820-6903

www.press.uillinois.edu